"Too many avoid the Beatitudes because cannot possibly attain. But Christy Boys are 'bad news' is exactly wrong. The mess gospel message. In Jesus's Beatitudes we find what is true of those who are in Christ, not what can never be attained. In meditating on Christy's exposition, tired and weary people will learn how to lean into the rest Jesus promised to all who accept his invitation. I highly recommend this study."

—**Dr. Chris Brauns**,
Pastor of The Red Brick Church; Author of *Unpacking Forgiveness*,
Bound Together, and *When the Word Leads Your Pastoral Search*

"I'm grateful for Christy Boys and this work that orients my heart to the words Jesus spoke to His followers, pronouncing not who we could be or should be but who we are by His Spirit. The struggle to walk in the reality of our identity as daughters and sons in this life is daily and often difficult. This workbook provides a beautiful opportunity to examine what Jesus declared about His followers in Matthew 5:3–10 as well as a thoughtful challenge to live in that reality every day. The work is beneficial for a Christ-follower at any stage in their sanctification. I appreciate the fresh look at a very familiar passage, and I look forward to sharing this helpful study with others."

—**Susan Wesley**,
Care and Support Associate of Clear Creek Community Church;
Wife of Bruce Wesley, Pastor of Clear Creek Community Church

"Being secure in who you are is one of the essential keys to life. In this study, Christy Boys leads us gently and clearly to the assurance of who we are through the breakdown of the Beatitudes as spoken by Jesus. Better understanding who I am has challenged me and made me more confident as a wife. As a parent, it has given me new ways to guide and instruct my children. I have been encouraged to be a better friend. My hope and prayer is that the truth of this study will do for so many more what it has done for me."

—**Cara Berkman**,
Wife of Lance Berkman, Professional Athlete

"Christy Boys unfolds the Beatitudes with exegetical insight and practical implications toward the joyful realities of our identity in Christ. *Be Who You Are* is a trusted biblical resource to navigate everyday life with conviction and hope."

—**Dr. Joseph P. Keller**,
Associate Executive Director of Grace Brethren Schools,
Biblical Counseling Coalition Counsel Board Member

"In a series of eight beautifully presented studies interwoven with challenging questions and applications, Christy Boys encourages each reader to find her identity and security in Christ and in her own position as a child of God and citizen of God's kingdom. Never preachy but scripturally solid and thought-provoking, this fresh look at the Beatitudes will be helpful for anyone . . . and for some, it will be life-changing."

—Lois McCall,
Retreat and Conference Speaker,
Teaching Leader of Houston's first Bible Study Fellowship class,
Board Member Emeritus of Bible Study Fellowship International

"Be Who You Are presents an incredibly impactful understanding of our identity in Christ. It is a powerful reminder of who God has already made me to be, in and through Jesus Christ. Whether laboring in an intense ministry overseas or standing in the checkout line at Target, the truth about my identity in Christ comes into play every single moment of the day. Christy's easily accessible and practical study has helped me to daily live out who I am; for that, I am grateful."

—Erin Fink,
English language university professor in East Asia

be who you are

discovering what the beatitudes reveal about identity

christy boys

LUCIDBOOKS

Be Who You Are
Discovering What the Beatitudes Reveal about Identity

Copyright © 2018 by Christy Boys

Published by Lucid Books in Houston, TX
www.LucidBooksPublishing.com

ISBN-10:1-63296-319-1
ISBN-13: 978-1-63296-319-2
eISBN-10: 1-63296-274-8
eISBN-13: 978-1-63296-274-4

Special Sales: Most Lucid Books titles are available in special quantity discounts. Custom imprinting or excerpting can also be done to fit special needs. Contact Lucid Books at Info@LucidBooksPublishing.com.

For Jack, Owen, Kate, Lucy, Sam, Jane, and Mae.

*My prayer is that you will each come to Jesus
and experience joyful freedom in being
who you are and loving what you have in him.*

Table of Contents

Special Thanks

To Cara for her encouragement and support;
Julie for her creative help and enthusiasm;
and all those who have learned with me through the years
to embrace who Jesus says we are.

Foreword

This new study has been years in the making.

For more than 40 years, Christy and I have served together in various pastoral settings, striving to make and mature followers of Jesus. In that time, we've grown—in our love for each other and also in our understanding of the gospel and its unending implications for daily living.

One of the most liberating truths in our own lives, and subsequently for others, is the assurance that comes from our union with Christ and the new identity we have in him. Too many believers derive their identities from their pasts, their abilities, or their circumstances. Too few comprehend who they really are as a result of the miracle of redemption in the gospel of Jesus.

Years ago Christy, while leading a group of ladies through a study on the Sermon on the Mount, recognized something life-changing in the Beatitudes. These statements, so often treated as a list of duties for the Jesus-follower, are actually declarations of truths rooted in what can be called gospel identity. What's more, the blessings Jesus announces are already present and accessible in daily living.

This workbook is the fruit of many years of her sharing these truths with women in all stages and walks of life. Her passion, combined with the help of these eager women and their humble authenticity, has resulted in a curriculum that will help you understand who Jesus says you are and all Jesus says you have in him through his grace.

I'm thankful you've chosen this study. I'm thankful Christy has labored to understand and then share these truths with others. And I'm thankful for the new identity we enjoy, revealed in the Beatitudes.

Our hope and prayer is that this workbook will help you realize and live out your true identity in Christ and then share it with others.

Michael Boys
Teaching Pastor, Christ Community Church, Houston, Texas

How to Use This Study

This workbook on what Jesus says about our true identity is designed ideally to be a nine-week group Bible study. The group participants should be encouraged to read the Introduction before the first gathering. The leader or facilitator should then lead a discussion through Stuff you Need to Know in the first group meeting.

Moving forward, participants should read and complete one chapter each week, which includes an attribute and an inheritance associated with the Beatitude of the week, and then return ready to discuss their experiences incorporating the Beatitude into their lives throughout the week. (You will discover that sharing experiences is a great encouragement.) After the participants share, the leader might read the first several paragraphs of the following chapter to give everyone a snapshot of the attribute and inheritance they will be focusing on over the next seven days.

It would be helpful for the participants to memorize Matthew 5:3–10 as they go along. Saying the verses together at the beginning of each gathering could be edifying.

A sample of a card to produce and laminate for each participant is included at the end of this workbook. The cards make it easy for each participant to have an ongoing, easily accessible reminder of their identity.

Alternatively, the workbook can be used individually or in a one-on-one relationship with each person sharing his or her impressions, thoughts, and experiences with the other.

Who in the world am I?
Ah, that's the great puzzle.

—Alice in Wonderland

———————

O LORD, you have searched me
and known me!

—Psalm 139:1

Introduction

This study is about one of the most basic questions you'll ever face in life: Who are you? Your answer, your understanding of your identity, matters a lot.

How you see yourself informs all of life. Your perception of yourself drives every choice you make. It governs the goals you set. It determines how you handle success and failure. It affects your relationships—how you respond to people and how people respond to you. How you live life is wrapped up in who you think you are.

In an ideal world, accurately figuring out who you are would begin with a healthy childhood. You would start learning who you are as a child, build on that understanding, and fully embrace your identity with confidence as you step into adulthood. Maturity and emotional health (what is often called human flourishing) would be the outcome.

However, we don't live in a perfect world.

How many people can say they experienced truly healthy childhoods? Who has figured out who they are with clarity and certainty? And how many have stuck with one idea? Not many.

Generally, people of all ages and stages of life sooner or later find themselves asking over and again, "Who am I?" They ask because they don't know, and deep down they instinctively have the sense that it matters.

But asking "Who am I?" often does not yield helpful answers. Many people allow family, peers, accomplishments, race, or the broader culture to answer the question. Others let fluctuating emotions dictate their sense of self. Confusion is often the result, and many end up in a so-called identity crisis. Some circle back there over and again, crying out to know who they really are in a world that offers a myriad of conflicting answers.

Our True Identity Can Be Known

How can we (those who have put their faith and trust in Jesus Christ) find a clear and accurate answer to the question "Who am I?" How are we to define our identity?

One summer afternoon, I was watching my little granddaughter and experienced one of those Hallmark moments I hope I never forget.

Jane is quite a little package. She is small and quick, sweet and mischievous, fragile and fearless, and utterly lovable—all at once. She reminds me of the little girl, Agnes, in the movie "Despicable Me." Irresistible!

She is the last of my son's four children. As the youngest, she has learned a lot very quickly. Most of the time, she sounds much older than she really is.

Jane was playing with her toys in the bathtub that afternoon and blurted out one of her way-beyond-her-years comments. I don't remember the comment (I am sure it was profound), but I'll never forget what came after.

I looked at her with delight and a big grin and said, "Jane, who are you?" She replied very matter-of-factly, "I am just a wet girl standing in a bathtub!" That she was. She was a whole lot more than that, but at the moment I asked, she was, indeed, a wet girl standing in a bathtub.

As Christians, we are sometimes very much like little (adorable) Jane. Our perception of who we are is limited to our current condition and circumstances. We find ourselves floundering in the moment (bad or good). We either don't know who we are or have forgotten who we are.

There is a way for us to know definitively who we are. We can go to the one who created us to understand who we are. There is a way for us to continually remember who we are. In knowing and remembering, we can flourish—wherever we are.

Our True Identity Is Transformative

Knowing who we are should begin with understanding what happened when we first put our faith and trust in Jesus as Lord and Savior. Something phenomenal happened. Consider what the Bible says:

> *2 Corinthians 5*
> *17 Therefore, if anyone is in Christ, he is a new creation. The old has passed away; behold, the new has come.*

We became a completely new person with a new and perfect identity when Jesus accepted us as one of his very own. That identity isn't something a healthy childhood led up to. Conditions and circumstances don't affect or change it. It is a gift from our Creator, and we can and should revel in it.

According to scripture, as descendants of Adam, we were born spiritually dead. Yet at the moment we came to belong to Christ, we were made alive.

Ephesians 2
4 But God, being rich in mercy, because of the great love with which he loved us,
5 even when we were dead in our trespasses, made us alive together with Christ—by grace you have been saved.

We were made spiritually alive *eternally* and given a new and perfect identity that was immediately real and wholly effective.

John 3
16 Whoever believes in him should not perish but have eternal life.

Our True Identity Is Secure

When we were made alive in Christ, we instantly became an actual son or daughter of God.

Galatians 4
7 So you are no longer a slave, but a son, and if a son, then an heir through God.

Ephesians 1
5 he predestined us for adoption to himself as sons through Jesus Christ, according to the purpose of his will,

Our adoption is permanent. We cannot and will not ever stop being sons and daughters of God. We are securely his. But that's not all.

In his omnipotent power, God miraculously went beyond adopting us. He imparted actual family likeness. He transformed us internally and gave us character traits that mirror the character of his one and only begotten Son—Jesus.

We can think of it this way. In becoming a son or daughter of God, we became family. As family, we possess a family likeness. In character, we resemble our older brother, Jesus, the God-man.

God sending his only begotten Son to the cross accomplished something truly amazing. He made a way for us to be redeemed, transformed, *and* uniquely adopted.

Our True Identity Is Revealed by Jesus

Early on in his earthly ministry, Jesus purposefully described the outcome of our internal transformation, providing specifics. He proclaimed these specifics in Matthew 5–7 in what is called his Sermon on the Mount.

When we ask the question "Who am I?" we find a solid and detailed answer in Matthew 5:3–10. There, Jesus gave a clear and accurate description of our new self.

Jesus said that each and every person who has been adopted by God the Father is poor in spirit, mournful, meek, hungry and thirsty for righteousness, merciful, pure in heart, a peacemaker, and one who is persecuted for the sake of righteousness.

He went on to say that those belonging to the Father are given lavish inheritances: the kingdom of heaven, the comfort of God, the new earth, God-originated satisfaction, the mercy of God, the ability to see God, and sonship with God.

Does all that sound just too good to be true? It's so far-reaching. We are meek? Pure in heart? Peacemakers? And more? Heaven and earth belong to us—already?

It is all true! Our truth-telling God says so.

Numbers 23
19 God is not man, that he should lie, or a son of man, that he should change his mind. Has he said, and will he not do it? Or has he spoken, and will he not fulfill it?

God doesn't lie, and he doesn't change his mind. He *has* given us a radical new identity. He has described who we are in him, and he has revealed our inheritances. And though at first it might seem hard to believe, it's true. We don't have to wish it were true or work to make it true. It simply is.

Our True Identity Is Complete

It is a great consolation to realize that our identity is not defined by our circumstances. It does not depend on achievements or performance. Family, peers, race, or culture aren't the determiners. Who we are doesn't ebb and flow with feelings and emotions. Our true self is not subject to change.

Here's what too many of us have gotten wrong for too long. We live as though we believe our new God-given identity is merely partial now and will come into fullness later. We function as though it will only become wholly effective once we reach heaven, once we arrive in the eternal presence of God.

In effect, we distort and complicate what Jesus made clear and simple. Typically, we do this in one of two ways. We either work hard to try to make our identity effective in the here and now, or we resign ourselves to just wait patiently until the hereafter for it all to happen.

Either of those paths—or anything in between—is not the path that God desires for us to follow.

It is not God's design that we try to finish what he started. And we don't have to wait for our physical death when we are in his actual presence for our new identity to take effect. To do so would devalue the work he accomplished for us.

Our new identity is already in effect. His desire is for us to live according to who we are right now. We already possess our inheritances; most of them are readily accessible to help us be who we are in Christ. He has provided everything we need to flourish.

When God does something, he does it wholeheartedly and completely. He leaves no gaps. He doesn't need our help. He doesn't leave us to flounder. Despite this fallen world, God's works *work*. He provides everything needed to make them work. And so it is with our identity. It works! There's no need to think it doesn't.

When we embrace who we are, access our inheritances, and live according to who we are, we become vibrant, striking pictures of God's handiwork. Those who have not yet been adopted into his forever family can look at us and see examples of what it looks like to become a true son or daughter of God.

Knowing Our True Identity Changes Everything

When we who belong to the God of the universe grasp the beauty of our *true* identity and the wonder of our inheritances in Christ, there is rich freedom and solid hope to be had—always. We can courageously walk through the good, the bad, and the mundane of life—and thrive.

The first step is to understand the scope of our identity, learn the breadth of our inheritances, and see how they all work together.

When we face problems and challenges—even the worst kind—we can reflect on how Jesus bolstered each one of our specific character

traits with a designated guaranteed inheritance that is already ours. Then we can find solutions—immediate solutions.

When we need to ask for God's help, we find strength in knowing that the God who has given us an eternity in heaven is very capable of giving us the moment-to-moment help we need. When we mourn over things that aren't right, we can draw on the comfort that is ours. When we find ourselves trying to help bring peace in difficult situations, we can rely on our sonship with the Father to know that we can bring peace the way he would bring peace. The possibilities are endless.

The God of heaven wants us to know who we are, revel in who we are, and bask in what he has given us. When that happens, he will be glorified. When he is glorified, we will be satisfied.

I hope you will be as surprised, amazed, and encouraged as I am—over and over and over again—as we consider and apply Jesus's teachings about who we are and what we have.

Write out a simple prayer asking the Holy Spirit to open your heart to hear what he wants you to hear from him about who you are and what he has given you. Remember, God is your Creator. He made you and then gave his one and only Son to die for you so he could remake you into someone gloriously new. You can trust him.

> I would like to live in the light of the Bright Morning Star, now and always, shining my own star light in reflection and glory to the Creator. Create in me a new heart, oh God.

If you have not yet trusted Christ as your personal Savior and don't yet have the new identity that Jesus gives to those who belong to him, read the following verses and pray the suggested prayer (or even your own prayer) with a sincere heart.

Romans 3
23 For all have sinned and fall short of the glory of God,

Romans 6
23 For the wages of sin is death, but the free gift of God is eternal life in Christ Jesus our Lord.

Romans 10

9 Because, if you confess with your mouth that Jesus is Lord and believe in your heart that God raised him from the dead, you will be saved.

10 For with the heart one believes and is justified, and with the mouth one confesses and is saved.

Suggested prayer:

Jesus, I know I am a sinner. I know that I need you to be my Savior. Please forgive me for my sins, cleanse me, and make me spiritually alive. Make me your child, and give me the new identity that you give to every true son or daughter of yours. Thank you, Jesus, for taking my place, dying for my sins, and conquering death.

Write a prayer specifically thanking Jesus for doing what you asked him to do.

Please help me come spiritually alive and alive to my purpose / destiny so I can live and thrive and serve.

All truths are easy to understand
once they are discovered;
the point is to discover them.

—Galileo

And you will know the truth, and the
truth will set you free.

—John 8:32

All truths are easy to understand
once they are discovered;
the point is to discover them.

—Galileo

And you will know the truth, and the
truth will set you free.

—John 8

Stuff You Need to Know

At first you might doubt the astounding reality of your true identity. That's the reason for this somewhat technical but important chapter. So hang in there!

On the face of it, to assert the present reality of our true identity might sound heretical. You will want and need proof that it is "true truth," as apologist Francis Schaeffer used to say. In other words, it is really true and not just something you're supposed to believe. It is all based on what God says in his written word, the Bible, about those who belong to him.

We need to begin by carefully explaining the reasoning at work in the specific scripture we will consider—Matthew 5:3–10. These verses contain what have come to be called the Beatitudes.

In the chapters that follow, we will apply this reasoning to each character trait found in the Beatitudes—one per verse. We will define the individual trait, show how the connected inheritance bolsters the trait, and give some suggestions for embracing who you are and finding hope in that reality. You are truly blessed!

His Words of Truth

At the outset, I want to be clear that only one opinion matters in considering the issues of life and death, time and eternity, *and* our true identity. Family, friends, and culture might all influence us regarding our identity, but God's view about who we are is the only view that really matters. His view is the *only* perfect and holy view.

We can trust his perspective because he is, first of all, our Creator. He made us, he knows us, and so, of course, he knows who we are. He gives us our identity. We can trust what he says because all that he says is true. As mentioned in the Introduction, he cannot lie (Numbers 23:19).

Beyond that, we know that God cares about us more than anyone else ever could. He has proven so by sending his only begotten Son to die for our sins and redeem us to himself.

Scattered throughout the Bible, especially in the New Testament, we find broad truths that God declares about our identity. The broad truths are realities such as we are made in his image, we are each a new creation, we are adopted, we are saints, and so forth.

The broad truths are important and helpful in understanding specific details. The details, however, will be our primary focus. They enable us to know who we are on a very practical level.

We can know what our hearts beat for, how we are wired, what we love, what we need, and what we most desire.

Our one true God, who always speaks truth, has made it possible for us to know our true selves with confidence and clarity. He has spelled out what it can look like for us to live out who we are—day-to-day—even moment-to-moment.

In what ways have you found the truths of the Bible, God's written word, to be more faithful and reliable than the contemporary wisdom you find in this world?

> Unchangeable
> Promises of destiny
> all inclusive – everyone is invited
> to the table to transform
> Eternal & still embodied

From your knowledge of the Bible, what can you confidently say about your identity as a Christian (e.g., the Bible tells me I am a new creation, etc.)?

> Fearfully and wonderfully made
> Child of God
> Christ – the bright morning star –
> lives within me thru the Holy Spirit
> I am a new creation

Consider Jesus's words, famously called the Beatitudes:
Matthew 5
3 Blessed are the poor in spirit, for theirs is the kingdom of heaven.
4 Blessed are those who mourn, for they shall be comforted.
5 Blessed are the meek, for they shall inherit the earth.
6 Blessed are those who hunger and thirst for righteousness, for they shall be satisfied.

7 Blessed are the merciful, for they shall receive mercy.

8 Blessed are the pure in heart, for they shall see God.

9 Blessed are the peacemakers, for they shall be called sons of God.

10 Blessed are those who are persecuted for righteousness' sake, for theirs is the kingdom of heaven.

What is your initial reaction to reading the Beatitudes? What do you think Jesus is saying?

> My brokenness is welcome, I can come
> as I am and be transformed
>
> I will be comforted in my mourning,
> dawn will come to break the dark
> night of the soul — darkness φ with

As Jesus spoke pointedly to his disciples on a mountaintop in his Sermon on the Mount, he was clear about the perfect identity of everyone in the family of God.

Jesus's words in the Beatitudes were—and still are—often misunderstood and misinterpreted as imperatives, or commands. In other words, the Beatitudes become a to-do list. But Jesus was simply speaking truth; he was describing reality. That truth, along with the foundational message of God's grace in salvation, cancels out any system of performing, achieving, and earning.

A sermon/address, believed by many to have been written by John Calvin, was delivered by his friend Nicholas Cop on November 1, 1533, to the University of Paris. It was on the Beatitudes. He defined the law and the gospel and then said, "Consequently, this Gospel does not impose any command, but rather [solely] reveals God's goodness, his mercy and his benefits."[1]

Give a couple of examples of how you might have been more concerned about trying to perform and achieve things for God instead of just accepting what he has done for you.

> ① Creating my identity through marriage
>
> ② Creating my identity in career/
> worldly success measurements

Why do you think Christians sometimes seek to impress and please God as opposed to living in and celebrating what he has done for them?

Assuming that we can win faith through good works rather than it being a gift

Idea of strain/pushing/pulling vs. flow

The Current Relevance of His Words

Regarding Jesus's words of truth, here are the first questions to ask: What was Jesus specifically saying in the Beatitudes? What truth was he communicating?

Oddly, Jesus's followers often muddle the meaning of what he said and make it much more difficult than it is. One reason is that the basic meaning tends to be counterintuitive for people who have been given a new identity but are still dragging around sinful flesh.

When we get to heaven, we will finally be rid of our sinful flesh, but for now—because of the pull of the flesh—we have to be careful and intentional to accurately understand what Jesus meant. We have to retrain our thinking so we comprehend these things correctly.

Scripture actually commands that we renew our minds to think the way God wants us to think.

Romans 12
2 Be transformed by the renewal of your mind, that by testing you may discern what is the will of God, what is good and acceptable and perfect.

The retraining process might be challenging and even frustrating at first, but eventually, it should become much easier.

———

Years ago, I determined to learn to play golf. My husband and I thought golf would be a good sport for us to share together, especially after our boys grew up and left home. That time was drawing closer.

Wow! What I learned quickly is that the golf swing is counterintuitive. Everything in me wanted to hit the golf ball just like I would hit a softball.

The outcome was not good. I would swing and miss—over and over again! That provided some awesome entertainment for others, but I didn't enjoy playing golf.

I finally figured out how to hit the tiny little golf ball, but then for a while, for whatever reason, I was also very naturally and consistently hitting it almost exactly 45 degrees away from where I was aiming.

The obvious solution seemed to be to adjust where I stood 45 degrees when I hit the ball. So I would set up to hit the ball (as I had been instructed) and then very strategically turn my body 45 degrees and swing away.

Surprisingly, it worked. The whole endeavor was hilarious to watch. I was providing some great entertainment for onlookers, but I was not enjoying golf—at all.

The 45-degree adjustment was not a long-term solution. The ultimate and best solution was for me to retrain my body to do something it was not naturally inclined to do.

Step by step, I began to learn. I started to get it. Step by step, I retrained my natural instincts. Golf was not nearly as hard as I was making it. I began to love and enjoy playing golf.

We can retrain ourselves to know who we are by God's design. We can love who we are and love being who we are. We can enjoy living life to its fullest this side of heaven.

Breaking Down His Words

As we approach Jesus's teaching, one by one we will break down the Beatitudes. That will help us retrain our thinking and keep things simple. For that to happen, we need to explain some key terms.

The grammatical term for stated truths is **indicatives.** Jesus is speaking indicatives in Matthew 5:3–10. He is not imparting commands, or **imperatives**—that is, things we must do (or not do). He is stating what is real and true about those who belong to him—those who are citizens of his kingdom and part of his family. He gives plenty of imperatives in other parts of scripture, but not in the Beatitudes.

What we will find is that each Beatitude emphasizes four specific truths—four indicatives.

> *An **indicative** is a grammatical mood that represents an act or state as an objective fact. The indication is that a statement is true, without any qualification being made. An indicative describes what is.*
>
> *An **imperative** is a grammatical mood that forms commands or requests, including the giving of prohibition or permission, or any other kind of exhortation.*

Together, these truths reveal one attribute of those who are in Christ as well as one inheritance possessed by those who are in Christ.

Consider the first Beatitude:

Matthew 5

3 Blessed are the poor in spirit, for theirs is the kingdom of heaven.

Here are the four truths to consider in this Beatitude.

Truth #1

Those who belong to God are given the kingdom of heaven.

The first truth to consider is a broad, gospel-rooted truth found in scripture as a whole and verified in this verse. This truth has to do with the specified inheritance mentioned in this verse.

We know by the whole of scripture that the kingdom of heaven belongs to all who belong to God.

The first truth in our breakdown is this: **Those who belong to God are given the kingdom of heaven.**

Truth #2

Those who have the kingdom of heaven are blessed.

In this verse, Jesus is saying there are those who are **blessed** by something in particular.

"Blessed are" is a common phrase used almost seventy times in the Old Testament. It could be defined this way: "It goes well with this person." It is not as casual as happy, *which reflects an inner emotion often based on circumstances. Blessed is an objective state of being. A person is blessed by something outside of themselves.*

The actual blessing referred to in Matthew 5:3 is the kingdom of heaven. We could accurately understand the verse this way: Blessed are those who have the kingdom of heaven, or **those who have the kingdom of heaven are blessed**.

Truth #3

Those who have the kingdom of heaven are the poor in spirit.

Jesus is *not* saying that the people who have the kingdom of heaven are blessed *because* they are poor in spirit. He is saying that those who

are blessed to have the kingdom of heaven *are* the poor in spirit. Poor in spirit is a description of those who have been blessed.

He is saying that the people who are poor in spirit are blessed because they have the kingdom of heaven, or **those who have the kingdom of heaven are the poor in spirit.**

Truth #4

Those who belong to God are poor in spirit.

Putting the first three truths together, there is a logical and final conclusive truth: **Those who belong to God are poor in spirit.**

Write down the four truths of Matthew 5:3 in order.

① Those who belong to God are given the Kingdom of Heaven
② Those who have the kingdom of heaven are blessed
③ Those who have the kingdom of heaven are poor in spirit
④ Those who belong to God are poor in spirit

We have broken the first Beatitude down into four truths—four indicatives.

In summary, one attribute of those who are in Christ is that they are poor in spirit. In other words, they are those who look to God for spiritual sustenance. (We will dig deeper into what it means to be poor in spirit in the next chapter.)

We also know that the inheritance of those who are in Christ (and therefore the poor in spirit) is the kingdom of heaven.

These are important truths. These are important indicatives. They are connected to each other. If we are in Christ, we are poor in spirit, and the kingdom of heaven belongs to us.

Based on the true truths found in Matthew 5:3, and if you are certain that you belong to God, fill in the following blanks:

I am __poor in spirit__.

The __Kingdom of heaven__
belongs to me.

What if you could know and embrace each one of your attributes listed in the Beatitudes with complete confidence? What if you

could know and access the unimaginable resources that you have to draw from? Knowing and accessing these would change how you live each day. It would drive your decision-making. It would determine how you function. It would affect all your relationships.

Suppose that when you face a difficulty—any difficulty—you could immediately know how to think of who you are and draw from your inheritances. You could walk through the difficulty with peace and victory. You could thrive!

So, at the end of the day, our sense of identity equips us for life when we recognize it, remember it, and then live it out.

A friend of mine (whose last name was Huguenard) was—in my opinion—a really good mom. One of the things she purposed to do with her children was give them a strong sense of what it meant to be a Huguenard. By my friend's definition, being a Huguenard meant a lot of different things, including telling the truth, being kind to others, acting like a lady, acting like a gentleman, and so on.

One day, my friend had to address the issue that her children had not been behaving as they should. They were not behaving the way they had been taught to behave. I clearly remember what my friend said to her children in that teaching moment: "You are Huguenards! Now act like Huguenards!" It wasn't that acting like Huguenards made them Huguenards. They were Huguenards, and they needed to act like who they already were. They were in the process of learning who they were—Huguenards. They were also learning to act like who they were.

This study's goal is to lead us to learn who we are and encourage us to live according to who we are. If you are a Huguenard, act like a Huguenard. If you are one of God's own, act like you are one of God's own. Gratefully, he has painted an accurate picture of what that should look like.

Breaking down each one of the Beatitudes can result in our being able to know and say who we are in Christ and readily access what we have with great confidence and conviction.

Because of what Jesus did on the cross and what he said, you can confidently say:

I am poor in spirit.

I am a mourner.

I am meek.

I am hungry and thirsty for righteousness.

I am merciful.

I am pure in heart.

I am a peacemaker.

I am one who is persecuted for the sake of righteousness.

You can confidently know what is already yours:

The kingdom of heaven

God's comfort

The new earth

God-originated satisfaction

Mercy

The ability to "see" God

Sonship with the heavenly Father

Being adopted by the God of heaven is truly miraculous. Your spiritual DNA is eternally changed, and you already have access to unfathomable inheritances.

John 8:32 says that we can know the truth, and the truth will set us free. Explain how you think that being able to embrace the truths of Matthew 5:3–10 might help set you free. What would that freedom look like?

> I already Am a Child of God — now act like one.
>
> I'd like to feel secure/confident/at peace in this identity, and I still have questions.

The truths of the Beatitudes can and will set you free if you understand them and live them out.

One Bible scholar said this about the Beatitudes:

This is not some far off identity to be attained by a select few. This is simply a genuine description of those who are God's children. Every one of us who is genuinely Christ's came with these attitudes, came through the process so that we have been transformed into beatitude-type people. We don't always manifest the same poverty

of spirit, or sorrow over our sin, or meekness, or mercy, or purity. We don't always manifest that hunger and thirst for righteousness as we should. We're not always the peacemaker we ought to be. But that is the character of our life. Those are the things that mark us out as God's children.[2]

—John MacArthur

——————

We trust that:

- you will be changed by a careful look at the Beatitudes—a careful look at who you really are.
- the Holy Spirit—who abides deep within you—will help your understanding.

- you will be amazed to know for certain what is yours and what you have to draw from.
- day by day, you will look more and more like him in a world where people are searching aimlessly to know who they are—and who he is.

I asked for help, which is the hardest
thing in the world.

—Marcia Wallace

————————

Make haste, O God, to deliver me!
O Lord, make haste to help me!

—Psalm 70:1

Those who are poor in spirit cry out
to God for his help—knowing they
are spiritually helpless.

You Are Poor in Spirit

Blessed are the poor in spirit,
for theirs is the kingdom of heaven.

—Matthew 5:3

Poverty is rarely viewed as a desirable state. And "poor in spirit" is not a phrase commonly used in our culture. Substituting the word *humble* for *poor* in this verse helps our understanding—Blessed are the humble in spirit.

Despite cultural resistance, Jesus pronounced that those belonging to him are humble in spirit. This teaching affirmed that humility of heart is directly related to one's spiritual relationship with God.

The Truths in the Verse

In order to retrain our thinking about what Jesus meant in Matthew 5:3, we return to our interpretive lens and consider the following four truths (indicatives) found in the verse:

1. Those who belong to God have been given the **kingdom of heaven**.
2. Those who have the kingdom of heaven are blessed.
3. Those who have the kingdom of heaven are the **poor in spirit**.
4. Those who belong to God are poor in spirit.

The first attribute of those belonging to God is that they are poor in spirit. One inheritance belonging to those who belong to God is the kingdom of heaven.

Poor in spirit

One who is poor in spirit does not have misdirected pride in their own spiritual riches. This is a person aware that they are spiritually unacceptable and helpless before a holy God. They are a spiritual beggar and quick to humble themselves before God, readily asking for and receiving his spiritual help. Their trust is in God to make them spiritually acceptable before him.

The kingdom of heaven

This is God's kingdom, the place where he rules and reigns. It is the eternal representation of his kingdom and eternal righteous reign. God the Father, God the Son, and God the Holy Spirit share in their glory together there.

Read Isaiah 66:2. Define "poor in spirit" in your own words.

A person simple & plain, reverently responsive to the word (msg)

Someone uncomplicated and authentic with a true openness and curiosity

Considering the definitions of "poor in spirit" above, describe a time when you felt like you were genuinely poor in spirit.

All of 2020, really.
Decision: exec, marriage, travel, living, start-ups... all of this

What was the outcome of your being "poor in spirit" before the Lord?

Feeling feeble, weak, broken-hearted
Sense of pervasive hopelessness surrounding my identity and feeling a total lack of choice

What the Verse Means

Unfortunately, many have heard the words of Matthew 5:3 as a command, an imperative. The prominent religious leaders of Jesus's day were given over to a performance-driven spiritual life. They heard and taught almost all of God's provisions as imperatives. Many people currently do the same, often unknowingly.

However, to interpret this verse as a command presents overwhelming problems regarding one's **salvation** as well as **sanctification**.

If this verse is a command, this is what we are left with:

- It is *our responsibility* to be diligent to make ourselves poor in spirit. Therefore, we are responsible to achieve and maintain this attribute.

> **Salvation:** *The deliverance from sin and its consequences.*
>
> **Sanctification:** *The ongoing process of being made holy and set apart to God.*

- It is *our responsibility* to be diligent to make ourselves poor in spirit so we will be rewarded with the inheritance of heaven. Therefore, we are responsible to earn one of our inheritances.

Think about the implications of interpreting this first Beatitude as a command in terms of our salvation. Doing so would lead to a performance-driven system of works-based salvation. One would have to do something—perform certain works—to earn the gift of heaven.

However, works-based salvation is completely contrary to the gospel.

Ephesians 2
8 For by grace you have been saved through faith. And this is not your own doing; it is the gift of God,
9 not a result of works.

A less severe (but still performance-driven) approach might interpret the first Beatitude this way: God promises heaven when we trust Jesus as Savior and then holds it in store for us. He will give it to us ultimately, but not yet. In the meantime, we should prove ourselves *worthy* of it by working diligently to *become* poor in spirit.

This interpretation also has overwhelming problems:

- From salvation on, we are left with the ongoing responsibility to make ourselves poor in spirit. This results in a system of works-based sanctification. Works-based sanctification is

also contrary to the gospel. It will wear you out and make you miserable.

- A complication of the performance-driven approach is that it is vulnerable to subjective, human evaluation and imperfect human achievement. For instance, if we have to work to make ourselves poor in spirit, we could never evaluate with any certainty how poor in spirit we really are. We could not accurately evaluate our poverty of spirit, and neither could anyone else. And sadly, because of our ongoing struggles with sin, we could never actually be completely and wholly poor in spirit. We could never measure up to God's standard.

These various scenarios leave the *performer* in a place that is unsustainable and inconsistent with the gospel. No matter what kind of performance-driven approach is pursued, the outcome is not the outcome that God desires. It is an approach that rejects what God freely provides. He freely gives salvation. He also accomplishes our sanctification through the work of the Holy Spirit.

Philippians 1
6 And I am sure of this, that he who began a good work in you will bring it to completion at the day of Jesus Christ.

In addition, the performer is vulnerable to adverse side effects. Suppose an honest, humble believer labors to perform yet inevitably fails to measure up. Failure, frustration, and defeat are the outcome.

Or suppose a performer is self-deceived and proud. Despite his unavoidable failure, he may foolishly deceive himself and proudly assume that he has done something that only God can do—indeed, something God has already done. Spiritual arrogance and deepened pride will be the result.

Either way, the performer is not fulfilled and cannot thrive. And God is not glorified.

According to Ephesians 2:4–9, what role do works have in our salvation?

Our works do not play a part, it's a gift. All we have to "do" is receive in faith which is also a remembering into our fullest identity as God's family

In verse 9, what does God's plan of salvation prohibit?

> We neither make or save ourselves.
> God does both the making and saving

The bottom line is that God hasn't left us to perform in order to establish our identity. Instead, he has graciously imparted a new identity to us. God doesn't and won't allow us to earn our inheritances. He has graciously given them to us. The glory is all his.

Jesus's shed blood paid for our redemption. Once we repented of our sins and trusted him to be our Savior, we became his, and he made us new—spiritually new. No tests to pass, no hoops to jump through, nothing to achieve. We were spiritually dead in our sins. We became spiritually alive solely by his doing. He remade us and gave us a new identity. There was nothing we could do—nothing to perform—to save ourselves. Only he can save.

By the same token, there is ultimately nothing we can do to sanctify ourselves. We are commanded to obey, and we *must* obey. But obedience doesn't sanctify. Only he can sanctify.

Regarding Matthew 5:3, our conclusion is that what some have assumed was an imperative (command) is really an indicative (a truth). Jesus has revealed that those who belong to him are poor in spirit. And as people who are poor in spirit, we have been given the gift of citizenship in the kingdom of heaven. He has stated what *is*, not what will someday be, based on our performance.

Being Who You Are

Poor in Spirit

Because of all that God has accomplished and provided, there is great joy and fulfillment in living out who we really are—the poor in spirit. Still, the concept of being poor in spirit can be confusing.

On the one hand, regarding spiritual riches, scripture speaks of them in a positive light (Ephesians 1:7–8; 3:8,16). But Jesus is talking about a kind of spiritual poverty that is also desirable. That spiritual poverty leads us to confess that we are, on our own, sinful and utterly dependent on our Savior for any and all spiritual riches. Being poor in spirit is declaring our deep need for God.

In fact, the first time we were ever poor in spirit he *caused* us to be poor in spirit. God's spirit made us aware of our spiritual bankruptcy and then drew us to him. He did this for his glory and our good.

John 6
44 No one can come to me unless the Father who sent me draws him.

We confessed we were sinners and could not save ourselves. We admitted we were spiritually destitute. We pleaded for his help and asked for his mercy. We prayed the same prayer the tax collector prayed in Luke 18:13: "God, be merciful to me, a sinner!" We cried out for his mercy and grace.

Just as he saw fit to initially cause us to be poor in spirit, he has also seen fit to gift us with the ongoing attribute of being poor in spirit. We became poor in spirit at the moment of our salvation—at his doing. We remain poor in spirit—at his doing. He transformed us in such a way that we can continue to plead for his help and for his mercy.

how is this different than codependency?

In your own words, describe the difference between being spiritually proud and being poor in spirit.

Spiritually proud is believing I can do everything on my own — being poor in spirit is admitting with humility I need help and am an open vessel to receive from God (proud = closed vessel)

Name some ways that God might be glorified when you act according to who you are—poor in spirit.

He that started a good work in me will carry it forward to completion — I press forward for that for which Christ Jesus claimed me.
God has room to garden in my heart.

If Matthew 5:3 is really a declaration that all who belong to God are poor in spirit, how is it possible that we Christians are sometimes *not* poor in spirit? How can we be declared to be poor in spirit and yet manifest spiritual pride?

Similar to the Huguenard children who periodically did not look like true Huguenards (see the previous chapter), how can we be poor-in-spirit Christians who are sometimes not poor-in-spirit Christians?

The answer is that those of us who have been made poor in spirit do not always live according to who we really are. We do not act like who we are. It is not that acting a certain way will establish who we are. God has already made us who we are. We just don't act like who we are.

It's been exhausting to pretend to be someone who I am not

Who we are should drive the way we act. If you are a Huguenard, act like a Huguenard. If you are poor in spirit (because he has made you poor in spirit) act like you are poor in spirit. That makes sense, right? Live like who you are.

Asking and pleading for God's help because of your spiritual bankruptcy should be a natural thing to do because you *are* poor in spirit. From day to day and moment to moment, humble yourself before him—your Creator—and ask for help. You can (and should) ask him for help with anything and everything.

Being poor in spirit doesn't have to be counterintuitive. The more you actively humble yourself and ask for God's help, the more intuitive it will be to do so. It is a matter of renewing your mind and redirecting your thinking about who you really are. The more you act like who you are, the easier it becomes.

What does it look like to embrace being poor in spirit?

———

A vibrant, gifted young woman found herself drowning in desperate circumstances. Not only had she become addicted to alcohol, she had allowed herself to be sexually abused at the hand of more than one man. Teetering at the brink of death was a familiar destination.

Understandably, she saw no hope. At her family's request, I reached out to this confused young woman in her 20s—so young yet so weary with life.

We started meeting on a regular basis. She shared with me how she trusted Christ as Savior as a child. She couldn't believe how far she had strayed away from him. She expressed deep remorse. Still, she was in utter despair at the thought of going on.

The first step was to help her understand her true identity. That's how she could go beyond her present circumstances. She could find hope in what God had done for her—who he had made her to be—instead of dwelling on all she had done to offend his holiness and all that had happened to her.

those occurrences weren't her true identity

I wouldn't accept her calling herself an alcoholic or let her speak as though the despicable things she had done (or others had done to her) defined who she was.

We started with the fact that she was poor in spirit—where Jesus started in the Beatitudes. I asked her to recall how she became one of Christ's own in the first place. She had humbled herself, repented, and believed in him as her Savior.

I suggested that she continue on—humbling herself—crying out to God for his help. I explained that she could do so because, as his daughter, she was poor in spirit. She need not drum up the ability to make herself humble enough. She need not white knuckle it, struggling along. Asking for the Lord's help would be acting in accordance with who she really was.

She began to understand how she could redirect her thinking about the way Jesus's words affirmed her God-initiated transformation. Asking for his help felt right to her. She began to thrive in asking for his help week after week. She was learning to continuously act according to who she really was—poor in spirit.

Regardless of our past or present circumstances, God made us poor in spirit. He has enabled us to humble ourselves and cry out to him for help whether we sin or are sinned against. When we ask for his help, we can thrive. Being poor in spirit is who we are.

Think of a challenging circumstance you are facing. How would owning your poverty in spirit help you begin to thrive?

Read Psalm 18:6. In this verse, how does God respond to the poor-in-spirit psalmist? What does this verse show that he will be willing to do for you, too?

Think of this: Stepping into heaven will not represent the greatest transformation you will ever experience. That transformation has already happened. When you step into heaven, the difference is that you will finally be rid of sin. You will be able to be who you are—perfectly. But you are already who you are.

The challenge is to know who you are, embrace who you are, and live according to who you are.

Loving What You Have

The Kingdom of Heaven

How would you describe heaven's kingdom to a child?

What does the phrase "kingdom of heaven" mean to you? What images appear in your mind?

At the moment of your salvation, what emotions did you experience when you realized you had received the gift of an eternal home in the kingdom of heaven?

Matthew 5:3 says that we are blessed to receive the inheritance of the kingdom of heaven. That is remarkable in light of the fact that prior to our salvation and before our miraculous transformation, we were in sinful rebellion against God's holy and righteous rule as King. Upon

our salvation, we were rescued and transferred into the kingdom of his beloved Son (Colossians 1:13).

What we might miss is that our undeserved inheritances from God are as freely given as our attributes. He lavishes inheritances upon those who belong to him. And unlike earthly inheritances, we don't have to wait to receive them.

Each of us has an imaginary rich uncle who has made hypothetical arrangements to grant us a theoretical inheritance. But in our future financial fantasy, there are no guarantees. Eccentric uncles change their minds. There are family disputes. There can be legal complications. Lawyers happen! Probate happens! We could wait a lifetime to come into our anticipated grand inheritance. We might not ever see a dime.

Unlike the waiting and uncertainty of receiving a tentative inheritance from a distant uncle, we who belong to Jesus receive our inheritances from our heavenly Father immediately when we are adopted—when he transforms us.

In the case of Matthew 5:3, God is not waiting for some future day to give the gift of the kingdom of heaven. He certainly is not waiting until we are deserving of it. We are not on probation.

God has already given us citizenship rights to his eternal kingdom of heaven in the here and now. We are not yet living with him in the kingdom of heaven. But through his grace, the kingdom of heaven is already ours.

Here are things we know about God's kingdom:

- His kingdom is everywhere. God is omnipresent (that is, he has no spatial limitation).
- His kingdom includes this world. The world is presently in sinful rebellion against his holy and righteous reign. He is in the process of rescuing and redeeming it.
- His kingdom includes heaven. Heaven is the eternal representation of his kingdom and righteous reign. It is his present home and his eternal home. It will also be the eternal home of all those who belong to him.

So when Jesus claimed that the kingdom of heaven belonged to the poor in spirit, he was revealing that rights, citizenship, and the guarantee of belonging to heaven's kingdom are already in our possession.

This inheritance of kingdom citizenship and our attribute of being poor in spirit correlate and work together perfectly. Our inheritance is there for us to draw on—to help us live out being poor in spirit. Our inheritance can prompt us to remember who we are and motivate us to live accordingly. Our inheritance is a source of security and help.

Remembering and acknowledging our poverty in spirit comes more easily when we appreciate the reality that we were born dead in our sin, reborn to new life, and gifted with all of God's kingdom—including eternal life and a home in heaven with him.

The kingdom of heaven became the motivation for the discouraged and defeated young woman to live out her true identity. She could thrive in knowing what she already had instead of settling for momentary and fleeting pleasures that paled in comparison.

She went on to make herself accountable to guard against returning to the bondage of addictions. There was great wisdom in that. The real freedom she experienced was found in embracing her identity and relishing her inheritances.

Read Revelation 4 and consider the picture of heaven presented there. What, in particular, are you excited to see and experience when you finally go there?

We can find solutions for living when we link our attributes and our inheritances together the way Jesus linked them. If you are not living out being poor in spirit, think on the inheritance Jesus linked with being poor in spirit.

When you remember that you have something as wonderful as the kingdom of heaven, you should naturally be humbled. Your inheritance can help you remember who you are. When you remember who you are, you can ask the God who gave you heaven to give you whatever else you need. And there you are, back to acting like who you are.

God is amazing. He made us who we are and then gave us the resources to live out who we are. He made us poor in spirit and gave us the kingdom of heaven. What more could we ask for or imagine?

God is our Creator and designer. His design is a perfect design. We have been made very, very well. We have been made well and given much.

The actual process of coming to fully understand who you are and what you have is an ongoing one. Once you come to know and embrace who you are as well as what you have, you can better be who you are. You are who God says you are, so be who you are.

The worst kind of sad is not being able to explain why.

—Anonymous

———————

Jesus wept.

—John 11:35

Those who mourn are those who are sad about what has been tainted by sin.

You Are a Mourner

Blessed are those who mourn,
for they shall be comforted.

—Matthew 5:4

Jesus declares that those who mourn are blessed. This is another unexpected concept. It's hard to understand how being a mourner is something positive. In our cultural context, it doesn't sound very appealing.

What is a mourner? The mourner of Matthew 5:4 is a person who is grieved over all that has been corrupted by sin. Mourners sense things that aren't right (by God's holy standard) and are faced with the reality that, in and of themselves, they cannot resolve the problem. They experience sorrow over sin.

The Truths in the Verse
Consider the following four truths (indicatives) that relate to Matthew 5:4:

1. Those who belong to God have been given his **comfort**.
2. Those who are comforted are blessed.
3. Those who are comforted are **those who mourn**.
4. Those who belong to God are those who mourn.

Jesus asserts that another positive attribute of those belonging to him is that they are those who mourn, and they are blessed with the inheritance of comfort.

Those who mourn

To mourn is to grieve. God's original creation in the Garden of Eden was perfect. Whatever is not as it was in the garden is something to mourn. Mourners are those who grieve over what is not right in this world from God's viewpoint. Mourners grieve over what has been tainted by sin and its effects in our world. Sin (whether one's own or the sin of others) causes suffering. Those who mourn are mourning over the suffering brought about by sin.

Comfort

The primary comfort for those who belong to God is the comfort of salvation—the assurance that God forgives us through Jesus, his Son. Yet there is also day-to-day and moment-to-moment comfort. According to 2 Corinthians 1:3–4, God is the God of all comfort.

God provides comfort in these ways:
- *His steadfast love provides comfort.*
- *His omnipotence provides comfort.*
- *His omnipresence provides comfort.*
- *His omniscience provides comfort.*

God comforts those who belong to him.

If you have trusted Jesus as your personal Savior and have a personal relationship with him, describe how that relationship began.

In what ways do you feel you were immediately comforted upon trusting Christ as Savior?

What the Verse Means

Considering the culture at the time Jesus spoke and our current culture can help us better understand the meaning of the verse.

In our culture, we associate mourning with death. We might express respect, honor, and perhaps even love by going to the funeral or memorial service for a deceased person. Depending on what our relationship was with that person, our expressions of grief might be recognized as mourning. Weeping over the loss of a close loved one is an obvious expression of mourning.

But apart from specific circumstances surrounding a death, we rarely think of ourselves as mourners. We don't represent ourselves as those who mourn.

We encounter people who refuse to mourn, at least outwardly. For them, mourning is a sign of weakness. They grit their emotional teeth, flex their determination muscles, and muster up the will to tough it out. Refusing to mourn is seemingly a noble quest.

In contrast, in Jesus's day, people *did* mourn. They did so publicly. They were comfortable with the idea of mourning. In fact, whenever a loved one died, those left behind wore mourning clothes (sackcloth) and marked themselves with ashes to signify that their hearts were scarred by their loss. They wept aloud. They went through an official period of public mourning. As odd as it sounds to us, families would even hire professional mourners to emphasize the magnitude of their loss.

Undoubtedly, the religious leaders and Pharisees of Jesus's day, given their propensity to affected spiritual appearances (see Matthew 6:16), took those culturally acceptable expressions of public grief and mourning to a different level. Likely, they put on sackcloth and ashes to express affected humility and artificial sorrow. Such mourning would have been an outward show—one more to-do in their performance-based system of gaining favor with God and impressing others.

In contrast, Jesus clarified that mourning is part of the identity of those belonging to him. It has everything to do with the heart and is part of each child of God's inner being.

All this begs the question: Why? Why would a good God declare that his own followers are, at the core of their identity, mourners? Why would he make us that way?

Because from the Creator's point of view, there is much to mourn over. All of sin and all of its effects are worthy of mourning over for those who are his. Because we belong to him (the God who hates sin),

we are hardwired to experience genuine grief over sin. We will naturally grieve sin. We are true mourners.

Think back to the beginning (or better, read about it in Genesis 1–2). Everything was perfect. There was no sin. There was no suffering. There was nothing to mourn.

After the disobedience of Adam and Eve, there was much to mourn. Genesis 3 describes the immediate, devastating, downward spiral of the human condition from the very moment man and woman chose to sin.

In Genesis 3, we read that Adam and Eve's eyes were opened to good *and* evil for the first time. Their eyes were opened to sin. That sin led to suffering. They had never known any sense of suffering. They began to suffer in many ways.

- Emotionally
 - They were immediately ashamed.
 - They knew immediate guilt.
 - They were fearful.

- Spiritually
 - They were separated from God.
 - They hid from God.
 - They died spiritually.

- Physically
 - Their bodies began to decay.
 - Physical death became pervasive and inevitable.

God mandated that Eve would experience pain in childbirth and wrongfully desire to rule over her husband. She had never known physical pain. Her desires toward her husband had always been pure.

Adam's work, which had been productive, honorable, and rooted in God's original creation mandate, would become difficult and toilsome. He would have to deal with thorns and thistles.

But it was even worse. The book of Romans tells us that it was through Adam's sin that sin and death then entered the *whole* world. (God held Adam responsible for his and Eve's sin in the Garden of Eden.)

Romans 5
12 Therefore, just as sin came into the world through one man, and death through sin, and so death spread to all men because all sinned.

Adam and Eve sinned, and the consequences immediately spread. Sin spread. Guilt spread. Death spread. Suffering spread. All of humankind to come was affected by one man's sin.

The effect of Adam's sin can be imagined, in part, by considering the effect of a chemical called Bitrex. Have you noticed that many harmful substances have an unbearably bitter taste? One little drop of Bitrex does it.

Bitrex is a compound that was originally discovered by a pharmaceutical company. It is so potent, it is claimed that a thimbleful of it added to an Olympic-sized swimming pool would noticeably taint the entire contents with unbearable bitterness.

Just a drop of sin—one act of disobedience—led to an outbreak. An uncontrollable viral infection erupted. After Adam and Eve's sin, there was a firestorm—a firestorm of immorality and death. Every person born was tainted with sin. Every person born was destined for death—spiritual death and physical death. Every person born in Adam was born with an empty spiritual identity.

Our God hates sin. Sin and all its effects cause those who love God to mourn. Sin has brought viral, devastating loss upon all humankind. Sin causes suffering. Like our heavenly Father, we are those who mourn over sin and the suffering it brings. Mourning is part of our identity.

Read Genesis 3:8–11. Considering sin and its effects, what should our mourning look like? Give examples of what we should mourn over.

According to Hebrews 4:16, what comfort is ours in Christ?

Being Who You Are

A Mourner

It should not surprise us that when Jesus, God's only begotten Son, walked on earth, he was a mourner. He was without sin, yet lived surrounded by and touched by the effects of others' sins. As the God-man, he suffered and mourned. He modeled mourning for us.

In the Gospels (the first four books of the New Testament that tell the story of Jesus's earthly ministry), Jesus was a mourner.

John 11
35 Jesus wept.

Here, Jesus is grieved over the suffering brought into creation by sin, manifested as physical death. His friend Lazarus died, and Lazarus's family was racked with grief and pain. So Jesus wept.

He knew that in the beginning, the Father's design was that there would be no death. Sin brought about death. Sin brought about the suffering of those whom he loved. Jesus mourned their suffering and wept.

In his human nature, Jesus mourned his own anticipated suffering. He knew that by his Father's design, he would bear the sins of all who would come to belong to him.

2 Corinthians 5
21 For our sake he made him to be sin who knew no sin, so that in him we might become the righteousness of God.

Facing the prospect of bearing our sin, Jesus was physically and emotionally overwhelmed with grief.

Luke 22
41 And he withdrew from them about a stone's throw, and knelt down and prayed,
42 saying, "Father, if you are willing, remove this cup from me. Nevertheless, not my will, but yours, be done."
43 And there appeared to him an angel from heaven, strengthening him.
44 And being in agony he prayed more earnestly; and his sweat became like great drops of blood falling down to the ground.

We mourn at the death of a loved one or friend. But consider our more fundamental identity as mourners. Think about what suffering and mourning might look like as we live out our faith day by day.

This mourning is not *self*-focused. Rather, this kind of mourning is *God*-focused.

As mourners, we mourn:

- suffering caused by our own sin.

 A young man with incredible potential yielded to a drug addiction. He made terrible choices. He ended up in prison. He was in Christ but chose a path of disobedience. He grieved his sin and the consequences he suffered. He mourned because he sinned against his God. He mourned because he is one who mourns.

- suffering caused by someone else's sin—directly or indirectly.

 A beautiful young woman in her early 30s tried to figure out how to "do life" as one of Christ's own. As a child, she had been sexually abused by a close family member. She suffered deeply because of someone else's sin. Part of her path toward wholeness was to realize that she is a person who mourns over sin—naturally. So she mourns her pain. She mourns the sin of someone who should have been trustworthy. She grieves the sin but is able to release the pain and thrive in who she is in Christ.

- suffering caused by spiritual warfare.

 A young man, eager to serve Christ, became oppressed by demonic influence. The evil forces seized an opportunity to confuse and pervert his good intentions. He experienced several mental breaks with reality. He suffered and now has to rely on medication to stay mentally balanced. He mourns the reality that there is evil in this world. Because he is in Christ, he is one who naturally mourns.

- suffering caused by the curse upon creation.

 People have suffered through hurricanes, tornados, earthquakes, tsunamis, floods, and more. Consequently, Christ-followers have lost their homes and all their material possessions. They despise the sin that brought natural disasters into the world (disasters that were not part of God's original creation). They grieve their loss and mourn because they are mourners.

- suffering caused by our fallen, imperfect bodies.[1]

 A devoted pastor and missionary suffered greatly in his twilight years from congestive heart failure and dementia. His body was worn out. He had done his best to invest in heaven. He had worked tirelessly at leading people to the Savior. It didn't seem right that he should suffer the way he did. His family watched as his suffering persisted. There was no stopping it. They grieved and mourned until he finally died. They found peace in their grieving and mourning because they are mourners.

What are some specific ways that you—or those close to you—have suffered?

Explain how that suffering is a direct (or indirect) result of sin.

When we stop to remember who we are, we can thrive in spite of our suffering. We don't have to stop the suffering. We don't have to try to fix things.

We remind ourselves that we are those who mourn what has been tainted by sin. We mourn our own sin. We mourn the injustice of the sins committed against us. Mourning is part of our identity. When we mourn, we are simply acting like who we really are.

What did your mourning look like in the example you cited above?

In what ways do you feel that your mourning has been God-focused?

Loving What You Have

Comfort

When we go back to the beginning and think about Adam and Eve's sin and its viral effects, we must also remember that God sent his one and only Son to die in order to provide a cure for sin. We sometimes miss some of the surprising aspects of God's incredible cure.

- Though God's cure was singular (a single act through the single God-man, Jesus) it was not for just one person. It wasn't a one-to-one cure. God provided a cure for all who would avail themselves of it. All those who would repent and believe could be cured.
- The cure was far greater than the disease. Jesus is far greater than sin.
- Upon receiving the cure, the recipient ends up in a better condition than Adam and Eve before there was any sin. The cure uniquely ensures that the recipient is given the righteousness of Christ.
- The cure includes unspeakable inheritances.

God's cure for sin is an amazing comfort. We are not merely mourners, but mourners who have comfort. The comfort we have brings real joy.

2 Corinthians 7
4 I am acting with great boldness toward you; I have great pride in you; I am filled with comfort. In all our affliction, I am overflowing with joy.

When we mourn, we can take hold of comfort. It belongs to us. We were gifted with it. We *will* be comforted.

Read Ecclesiastes 4:1. Describe the difference between those who are living under the sun and don't belong to God (those in Adam) and those who do belong to God (those in Christ).

What does God say he will do in Isaiah 66:13 and Jeremiah 31:13?

The first time we were ever comforted was at the moment of our salvation. We mourned our sin, and we were comforted with forgiveness and the inheritance of an eternal home in heaven.

But our comfort goes beyond the gift of heaven. It is an ongoing experience. It is available—always. Read the following verses and explain how our ongoing comfort is described.

Psalm 23:4

Psalm 71:21

Psalm 119:50

Psalm 119:52

Second Corinthians asserts a mysterious truth about the comfort we have inherited through Christ. Through our suffering, we have the opportunity to share in Christ's sufferings as well as his abundant comfort. We are able to share his comfort with others.

2 Corinthians 1
3 Blessed be the God and Father of our Lord Jesus Christ, the Father of mercies and God of all comfort,
4 who comforts us in all our affliction, so that we may be able to comfort those who are in any affliction, with the comfort with which we ourselves are comforted by God.
5 For as we share abundantly in Christ's sufferings, so through Christ we share abundantly in comfort too.
6 If we are afflicted, it is for your comfort and salvation; and if we are comforted, it is for your comfort, which you experience when you patiently endure the same sufferings that we suffer.
7 Our hope for you is unshaken, for we know that as you share in our sufferings, you will also share in our comfort.

Name some ways you might have shared in the sufferings of Christ. (Remember, he felt pain over sin, he experienced grief, he was isolated and alone, he was betrayed, etc.)

In this passage of scripture, Paul also declared his willingness to share his comfort with others. Give some examples of how you might share your comfort with others.

When we find ourselves searching for comfort, we can remember our inheritance of comfort. That inheritance then points us back to

who we are—mourners. As sure as we live and breathe, we will always have issues and circumstances we must mourn.

We are those who mourn. But we are never to live as victims of mournful circumstances. Instead, we belong to Jesus who identifies us as those who mourn. We have been given an identity as mourners.

We mourn, we bask in his comfort, and we are freed. We find confidence in knowing exactly who we are. We find security and hope in our inheritance. We find freedom in our identity.

You see, it's been our misfortune
to have the wrong religion. . . .
Why did it have to be Christianity
with its meekness and flabbiness?

—Adolf Hitler

———————

I, Paul, myself entreat you, by the
meekness and gentleness of Christ.

—2 Corinthians 10:1

Those who are meek are not weak;
their strength is under control.

You Are Meek

Blessed are the meek,
for they shall inherit the earth.

—Matthew 5:5

The use of the word *meek* is uncommon and rather unfamiliar to us. One of the current definitions offered by the *Merriam-Webster Dictionary* is "deficient in spirit and courage; submissive."

But Jesus is not advocating a deficiency in spirit or courage in this verse. Rather, he is promoting power that is under control. In the New Testament, Paul described Jesus as meek.

The Truths in the Verse

Here are four truths (indicatives) that can be found in Matthew 5:5:

1. Those who belong to God have been given the **earth**.
2. Those who have the earth are blessed.
3. Those who have the earth are those who are **meek**.
4. Those who belong to God are those who are meek.

God graciously gifted us with the attribute of meekness. In great generosity, he has given us the earth.

In 2 Samuel 22:32–36 David speaks of God's strength and gentleness. Give an example of how you have seen God's strength on display. Give an example of how you have experienced God's gentleness

The meek

The word meek *in this verse comes from a Greek word meaning being mild, gentle, even tenderhearted. Although mild, gentle, and tenderhearted, the person Jesus is describing here is not weak in any sense. In fact, they are strong. They are strong enough to bring their strength under control. They can be likened to a lion that has been tamed.*

The earth

After God made man in his own image, he gave man dominion over the earth, the fish of the sea, the fowl of the air, and the animals. The earth includes all of God's creation over which our first parents (Adam and Eve) were given responsibility. The earth was marred because of their sin and has not yet been restored to what it was before sin. One day, it will be restored. Paradise will be regained. The earth that Jesus speaks of in this verse is that new earth.

In Matthew 19:14, Jesus said, "Let the little children come to me." He was kind and gentle. In Matthew 21:12, we are given the account of Jesus driving the money changers out of the temple. He overturned tables! Read 2 Corinthians 10:1. In what two ways does Paul say he is like Christ as he greets his brothers and sisters?

Describe a life circumstance wherein you hope to be more like Paul and Jesus in their meekness.

What the Verse Means

What Jesus meant by *meek* was countercultural in his day and time. The actual Hebrew word of the Old Testament scriptures (that is, the word that correlates to the New Testament Greek word translated *meek* in our Bibles) was used to refer to the lowly or poor.

Jesus was using the word for *meek* in a cultural climate where the religious leaders (specifically the Pharisees and Sadducees) were not lowly or poor in *any* sense of the word.

The Sadducees were part of the Levitical line that had seized political position a hundred years before Jesus came along. They were aristocrats. They were wealthy and saw themselves as lords of the temple. Functionally, they were submissive to no one.

The Pharisees functioned as lords over the scriptures. They were rule makers—for everyone. The people generally recognized them as such and typically deferred to them.

The Sadducees and Pharisees were the antithesis of the lowly and poor. They were surely not meek by Jesus's definition. The meekness that Jesus spoke of is the polar opposite of those who are impressed with themselves or reliant on their own power or position.

The meek are not pretentious. They are not self-exalting. They are not trying to advance and defend themselves.

The meekness Jesus was describing resides in a person who is both poor in spirit before the Lord and lowly in the sense that they are humble before the Lord.

By Jesus's definition, the quality of meekness is not something to be acquired or accomplished. It is uniquely given by God to those who belong to him. In Jesus's view, the meek exalt others; they are considerate. Their power is used in defense of God and what God cares about—not in their own defense and what they care about.

Those who are meek are not motivated by their rights. They don't seek after their own due. There is no sense of entitlement. They recognize that from the moment of their birth, they are due nothing.

The meek put their trust in God. They delight in him and trust him to provide what they need. The meek person lives in the reality that impossible things are made possible through and from God's power—not their own.

Matthew 19
26 But Jesus looked at them and said, "With man this is impossible, but with God all things are possible."

Considering Matthew 19:26 and the quality of meekness, name some things in your circumstances that might seem impossible from a human perspective, yet possible in light of God's power and strength.

Read John 14:26. The Holy Spirit indwells every person who belongs to the God of heaven. Give some examples of how you have relied on God's strength through the Holy Spirit's working in your heart.

In Psalm 37:11, the Psalmist declares that the meek are blessed with the inheritance of the earth. He is speaking of the earth that will be made new when Jesus comes again.

Psalm 37
11 But the meek shall inherit the land and delight themselves in abundant peace.

Being Who You Are

Meek

Compared to the other Beatitudes, perhaps there is a need to be more intentional about renewing our thinking concerning the God-given quality of meekness. This is because we are bombarded with messages extolling attitudes that are the opposite of meekness.

Our culture's cry is to use any amount of power (and control) we can possibly muster to get what we want on this earth. You snooze, you lose! Look out for number one! That pressure, coupled with the reality that we are dragging around sinful flesh, demands that we very deliberately renew our minds (Romans 12:1–2) regarding what it means to be meek.

A great place to begin to better understand all this is to look at Jesus's perfect example. Jesus was perfectly meek when he walked on this earth.

2 Corinthians 10
1 I, Paul, myself entreat you, by the meekness and gentleness of Christ.

Consider some examples of Jesus's meekness:

- **Jesus entered the world in humility.**
 Jesus came to earth in the form of a helpless baby. He was almighty God joined with human nature—in a sense, wrapped in human skin. He, the infinite and unlimited one, took on the form of those who are limited—human beings.

 Luke 2
 7 And she gave birth to her firstborn son and wrapped him in swaddling cloths and laid him in a manger, because there was no place for them in the inn.

- **Jesus presented himself in lowliness.**
 When Jesus came into the city as the Messiah, he didn't come as a warrior on a white horse ready to conquer the world. He came riding in on a colt (the foal of a donkey) that was considered to be low-class transportation. He was meek. He was the embodiment of power under control.

 Matthew 21
 5 "Say to the daughter of Zion, 'Behold, your king is coming to you, humble, and mounted on a donkey, on a colt, the foal of a beast of burden.'"
 6 The disciples went and did as Jesus had directed them.
 7 They brought the donkey and the colt and put on them their cloaks, and he sat on them.
 8 Most of the crowd spread their cloaks on the road, and others cut branches from the trees and spread them on the road.
 9 And the crowds that went before him and that followed him were shouting, "Hosanna to the Son of David! Blessed is he who comes in the name of the Lord! Hosanna in the highest!"

- **Jesus loved children and dealt with them gently.**
 In a culture where children were not greatly valued, Jesus reached out to the children in spite of his disciples' attempts to keep them away.

Matthew 19
14 But Jesus said, "Let the little children come to me and do not hinder them, for to such belongs the kingdom of heaven."

- **Jesus expressed righteous anger.**
Jesus's anger was real, yet always controlled and channeled in righteous ways. He was angry over sin and its effects. But his anger was consistently appropriate and just. His righteous anger was an expression of his strength under control.

Matthew 21
12 And Jesus entered the temple and drove out all who sold and bought in the temple, and he overturned the tables of the money-changers and the seats of those who sold pigeons.
13 He said to them, "It is written, 'My house shall be called a house of prayer,' but you make it a den of robbers."

- **Jesus was silent when ridiculed and reviled.**
Jesus did not return evil for evil. He entrusted himself to the Father—the righteous and ultimate judge—to bring justice.

1 Peter 2
23 When he was reviled, he did not revile in return; when he suffered, he did not threaten, but continued entrusting himself to him who judges justly.

Matthew 27
12 But when he was accused by the chief priests and elders, he gave no answer.
13 Then Pilate said to him, "Do you not hear how many things they testify against you?"
14 But he gave him no answer, not even to a single charge, so that the governor was greatly amazed.

- **Jesus submitted when crucified.**
He could have called twelve legions of angels and escaped crucifixion, but he did not. Instead, he was silent.

Matthew 26
53 Do you think that I cannot appeal to my Father, and he will at once send me more than twelve legions of angels?

We can see in Jesus's example that meekness is not being without power. Meekness is not impotence. Meekness is power under control.

Which example of Jesus's meekness is most striking to you?

How does Jesus's meekness specifically motivate you to be meek in your own circumstances?

———

I love horses. I think they are one of the finest of God's creations. I don't have to ride one to appreciate them. I love just watching them.

Years ago, I met a woman who was a horse trainer. She wanted to learn more about God, and I wanted to learn more about horses. So I would go over to her place, and we would trade what we knew. We talked about God while we worked with the horses. I learned a lot.

I learned to have a healthy respect for horses. They are powerful. A horse usually weighs a thousand pounds or more. As a powerful beast, they can choose whether or not to follow the commands of a rider sitting on their back—a rider weighing as little as 1/10 of their weight.

As I spent time with my friend, I got to see all a horse can do—both bad and good.

Kim worked with a horse she called Mountain. He was very tall, athletic, fast, and fierce. He was beautiful and graceful. But Mountain had a very difficult time bringing his power under control and responding to Kim's instruction. What he did—when he did not bring his power under control—was destructive. He was dangerous. It wasn't pretty.

I watched Kim work with horses that would so much more willingly bring their power under control. Sometimes, Kim would ride with no

reins, no bit, no bridle—and guide the horse just by flexing muscles in her body. It was awesome to watch. It was unbelievable!

I came to think that there was nothing more beautiful than a powerful horse—one that could dominate any human being—bringing its power under control. When that happened, the horse made the rider look beautiful, too.

We humans are each powerful creatures whether we perceive it or not. Each of us is gifted with abilities, resilience, talents, and resources, all flowing from our inherent, abiding (although tainted) image of God. All these represent a fountain of power.

Our gifts and abilities can be used in powerful ways and in ways that are meek, or they can be used in ways that are self-driven, selfish, and ultimately characterized by power out of control.

The picture of a horse bringing its power under control is a great picture of what it can look like for a human being to bring his or her power under control. Without relinquishing God-given capabilities and gifts or being weak, a person can—in meekness—glorify God with the help of the Holy Spirit.

A wife can do this with a husband. A husband can do this with a wife. Friends can do this with each other. An employee can do this with an employer. An employer can do this with an employee. Church leadership can be meek in leading. Church members can be meek in following.

Meekness is part of the identity of those belonging to the God of heaven—the Creator. When we are meek, we are being who we really are, who God designed us to be. Being meek is part of what makes it possible for us to be obedient to the God who made us. We can be meek and bring him great glory.

Cite some specific examples of when you have seen someone bring God glory by choosing to walk in meekness.

Name some instances in which you could choose to relinquish power and live out your God-given attribute of meekness.

Loving What You Have

The Earth

Because of the tendency to resist being meek for fear of being weak, it is helpful that meekness's corresponding inheritance is the earth—the whole earth. The inheritance of the earth bolsters us to be meek and provides help when we struggle. We *are* meek. Our challenge is to live out that meekness. So how can we link our inheritance to our attribute of meekness and actually be meek?

If We Are Afraid

If we are fearful about not having all that we need—and even maybe a little bit of what we want—we don't have to be afraid. We can focus on being meek and rest in what we already have—the whole earth.

We are not to lie back and choose passivity. Rather, we must be strong in a God-glorifying way. To be weak would not reflect who we are. There is no place for our doing nothing. Meekness is not weakness.

Surely the one who has given us the earth can be trusted to provide. We don't have to frantically work to take care of ourselves. Most likely, he will provide more than we need. He already has. There is no need to flounder in fear. There is no place for feeling like you have to do it all. God will take care of you. He *has* taken care of you. He has promised you the new earth. He will reclaim it from the power of sin, and he will hold it in store for you. It is yours.

Genesis 3:15 holds a promise about who will be victorious over sin in the end. (The serpent is the evil one; the seed of the woman is the promised Messiah, Jesus Christ.) What does this verse promise will happen to the evil one?

In what way has this already happened (see John 19:30, Colossians 2:13–15)? In what ways is this still a not-yet fulfillment?

How can the promise of Genesis 3:15 help you not be fearful?

Note that the promise above is given in the context of our first parents' losing dominion and authority over the earth. Jesus's teaching regarding the meek inheriting the earth reverses that loss. The Father promised it, Jesus has made it possible by conquering sin and death, and the Holy Spirit will bring it to pass.

If We Want to Fight

If we are driven to fight to get all that we can—and maybe *however* we can—we must stop to remember what we already have. The whole earth belongs to us. Everything is ours as far as the eye can see. There is no need to fight for it. We can bring our strength under control and be meek.

Name some ways you can be grabby or tend to fight to get what you think you need—or what you want.

Read Ephesians 3:20–21. Describe how the truth of these verses can help you trust God as you try to be who you really are.

According to these verses, explain how God accomplishes what he will do for us and in us.

If We Crave Power

If it is power that we pursue, the exercise is the same. (And note that sometimes power looks like control.) When we live under the illusion that power will get us what we need (as well as some of what we want), the outcome is not pretty. We *are* meek but we aren't *being* meek. We can fall into trying to rule over anything and everything.

We can try to control family members, friends, employees, people in the community, and people in the church. But there is no need to be pushy and demanding. We must bring our power under control. God has given us everything—the whole earth.

In what areas do you think you have given in to sin and tried to assert power over other people? Name some specific relationships that has affected.

Because of God's promise, how can you be motivated to stop pursuing power and be meek?

If We Are Desperate

Finally, we can end up desperate and attempt to exercise complete rule over ourselves, if nothing else. For example, we can become workaholics who think we alone can provide and *must* provide. Or we obsessively work to stay fit and healthy—at any cost—in order to obtain a sense of security and control. Worse still, we develop an eating disorder to gain control. We convince ourselves that there is no room to be meek. We must ruthlessly press on—even at our own cost.

But all this is pointless and can, at times, be harmful—even dangerous. No need to obsess. No need to overachieve. We have already gained the whole earth.

We can reduce our fears, relinquish our selfish pursuits, and redirect our misguided efforts by focusing on what we have in Christ. Because of who we are and what we have been given, we can bring our strength under control. We can be meek.

There is hope. We can rest in the Lord and his provisions. We can rest in who we are and what we have. He has made us meek and gifted us with the whole earth, which is more than we will ever need and more than we could ever want.

Explain how the following verses are a comfort for you as you remember to be confident in what God has given you.

1 Corinthians 3
21 So let no one boast in men. For all things are yours,
22 whether Paul or Apollos or Cephas or the world or life or death or the present or the future—all are yours,
23 and you are Christ's and Christ is God's.

We belong to the one who made us, the one who made us meek. The God who cannot lie has said that all things are ours for as far as the eye can see. There is rest in that reality.

A fool is thirsty in the midst of water.

—Ethiopian proverb

————————

I stretch out my hands to you;
my soul thirsts for you
like a parched land.

—Psalm 143:6

Those who are hungry and thirsty
for righteousness crave
the righteousness of God.

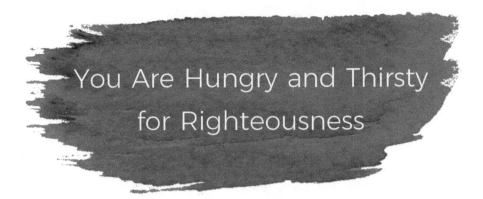

You Are Hungry and Thirsty for Righteousness

Blessed are those who hunger
and thirst for righteousness,
for they shall be satisfied.

—Matthew 5:6

When Jesus spoke of the person who is hungry and thirsty for righteousness, he was talking about someone with an intense hunger and thirst for the righteousness of God.

Imagine a person stranded in the desert—starved and thirsty—with nothing to eat and nothing to drink. This person's hunger and thirst would be insatiable. Jesus is saying that those who belong to him have an ongoing, never-ending, constant, and insatiable desire for his righteousness.

The Truths in the Verse

Here are the indicatives of Matthew 5:6 we can cling to:

1. Those who belong to God have been given **satisfaction**.
2. Those who are satisfied are blessed.
3. Those who are satisfied are those **who hunger and thirst for righteousness**.
4. Those who belong to God are those who hunger and thirst for righteousness.

According to Jesus, an attribute of those who belong to God is that they are hungry and thirsty for righteousness. And accompanying this attribute is the inheritance of satisfaction.

(margin note, left:) dis-union (sin) vs. union (whole) righteousness = fulfilling the standard; "whoreness;" completeness

(margin note, right:) Christ = The Bright Morning Star

Those who hunger and thirst for righteousness

To be hungry and thirsty is to be famished for something—to crave something. These people are famished for righteousness; they crave the righteousness of God. At the moment of salvation, the Holy Spirit produces a craving for a saving righteousness. He also gives a continuing hunger and thirst for a sanctifying righteousness. Those who belong to God are always hungry and thirsty for righteousness.

Satisfied

Satisfaction has the idea of eating to one's fill—full to the point of contentment. This word is used in the New Testament to refer to eating actual food. For example, it is used specifically when Jesus fed the multitude with five loaves and two fishes (see Matthew 14:20, 15:37).

Just as being hungry and thirsty for righteousness is a perpetual condition, satisfaction is perpetually available. Those who belong to Jesus are always hungry and thirsty for righteousness. And those who belong to Jesus can always be satisfied.

What the Verse Means

What Jesus said about hungering and thirsting after righteousness did not resonate with the religious leaders of his day. The Pharisees and Sadducees worked hard to give the outward appearance of craving righteousness. In reality, they weren't hungry or thirsty for righteousness at all. They hadn't been spiritually awakened. They weren't hungry and thirsty for anything truly spiritual. They were still spiritually dead in their sin. Dead men don't hunger and thirst.

(margin note, left:) dulled; light was not shining; dis-union; dis-ease

Romans 9
31 But that Israel who pursued a law that would lead to righteousness did not succeed in reaching that law.
32 Why? Because they did not pursue it by faith, but as if it were based on works. They have stumbled over the stumbling stone.

Romans 10
3 For, being ignorant of the righteousness of God, and seeking to establish their own, they did not submit to God's righteousness.

Instead of being made alive in Christ, they attempted to build and establish their own righteousness through performance. They were driven to achieve. Their righteousness was inauthentic. It was self-righteousness.

The Bible speaks to the inauthentic, phony righteousness of Satan and his forces. Remember, Satan disguised himself before Adam and Eve, and they were fooled. That is how sin entered the world in the first place.

2 Corinthians 11
14 And no wonder, for even Satan disguises himself as an angel of light.
15 So it is no surprise if his servants, also, disguise themselves as servants of righteousness. Their end will correspond to their deeds.

Many people entrenched in empty religion are only disguised as servants of righteousness. They are ignorant of God's righteousness, have not submitted to his righteousness, and *cannot* hunger for it. The best they can do is pursue self-righteousness and try to appear outwardly as though they are hungry and thirsty for righteousness. They disguise themselves. Sadly, sometimes they even fool themselves.

Moralism says to unbelievers, "Be what you are not."
Christianity says to believers, "Be what you are."[1]

—Alistair Begg

Every human-focused, performance-based religion marks out a path that is exhausting, inauthentic, and futile. No one can make himself or herself as truly righteous as they need to be.

Matthew 5
20 For I tell you, unless your righteousness exceeds that of the scribes and Pharisees, you will never enter the kingdom of heaven.

Even though you are already in Christ, how might you have fallen into the trap of trying to achieve your own righteousness? What does that look like?

[handwritten: ① Identity through marriage (wife/mom)]
[handwritten: ② Identity thru career/success/achievement]

[handwritten margin notes: EFFORT-FULL vs. EFFORT-LESS → BE WHO YOU ARE]
[handwritten margin notes: Be free in who Jesus paid you to be ♡ hmm...]
[handwritten margin notes: "Church" The Bride of Christ]

69

Psalm 23:3
True to your word, you let me
catch my breath
and send me in the right direction

Read Psalm 23:3 and Proverbs 12:28. Explain how we are to walk in righteousness and walk where the path of righteousness will lead us.

God is sending me in the RIGHT
direction

Good men & women travel right
into life (path/journey/LIFE)

We can rest assured that when God commands that we pursue righteousness, he has made us hungry and thirsty to do so. Our new normal is longing to pursue righteousness. We still wrestle with our sinful flesh (and will do so until we reach heaven), but we have been made new with a new hunger and thirst.

Think of our plight if God had not changed our spiritual appetite—had he not given us our new hunger and thirst. We would have to *strive* to make ourselves hungry and thirsty for the right things in order to be obedient. That would be exhausting.

But our faithful and wise God declares through Jesus that he has made us exactly as we need to be. We are hungry and thirsty for righteousness. When we follow his commands, we don't have to force ourselves to desire doing so. We will naturally desire to obey when we embrace who we are. We will still have to choose to deny our sinful flesh, but the hunger and thirst to do what is right is there. He put it there.

How might you change your thinking about being obedient to God's commands in light of the fact that being hungry and thirsty for righteousness is part of your identity?

I Choose life

I accept God's gifts and direction

I am not saved by works — I can
now truly rest righteously

Read 1 Samuel 26:23 and 2 Samuel 22:21, 25. What does the Lord promise when you are faithful to pursue righteousness?

2 Sam

God made my life complete when I placed all of the pieces before him (21) When I cleaned up my act, he gave me a fresh start

I fell put together, I'm watching my step God rewrote the text of my life when I opened my eyes

For those who are in Christ, Jesus declares that he not only produces the right hunger and thirst; he provides the satisfaction of that hunger and thirst. He takes care of it all. It all depends on him. He gets all of the glory!

the book of my ♥ to his eyes.

Being Who You Are

Hungry and Thirsty for Righteousness

How can we live in the fullness of being hungry and thirsty for righteousness? Craving righteousness shouldn't lead to a life of bondage with little freedom. This reality should bring us relief, security, and joy.

Think of it this way. When we went from being in Adam to being in Christ, we were dead and then made alive. Things changed—drastically. We came to life, and we were immediately hungry.

One of the first things a newborn baby does is cry. The newborn very naturally wants food—immediately. When we were born again and came alive spiritually, we craved righteousness—immediately. That hunger and thirst is part of who we are.

immediacy of craving for life

We were, first of all, hungry and thirsty for saving righteousness. The Holy Spirit produced in us a burning desire to be cleansed of our sin and made righteous. Many of us can remember that moment. We can even remember the feelings we experienced in the moment of our salvation—joy, relief, wonder, rest, amazement, and so on. We were hungry and thirsty for righteousness, and God satisfied that hunger and thirst. He fed us. He filled us. He **imputed** to us the righteousness of Christ.

2 Corinthians 5
21 For our sake he made him to be sin who knew no sin, so that in him we might become the righteousness of God.

He didn't stop at imputing his righteousness to us. Experiencing saving righteousness was only the beginning. He went on from there. The Holy Spirit produced in us an ongoing hunger and thirst for sanctifying righteousness. That is what affects our daily living. That ongoing hunger and thirst is what causes us to pursue righteousness.

> **Imputed**
> *Upon repenting and believing in Christ, a person is declared righteous. This is a judicial or forensic concept. The righteousness is not the believer's own righteousness. Christ's righteousness is imputed to the believer.*

Suppose you decided to go on a crash diet. Suppose you had been hungry and thirsty for unhealthy food—food that wasn't good for you. You had gorged on junk food, sweets, salty foods, fattening foods, and more. You had followed your hunger and thirst, filled up on those things, and the effects were horrific.

You didn't feel good. You gained weight. You began to develop health problems such as high blood pressure, heart disease, and so forth. One of the hardest hurdles to jump over would be retraining your body to hunger and thirst for the right things. That change would be brutal. It would be so hard! You might not be able to do it. Many of us can't do it. We can't change our hunger and thirst. So the physical problems go on and on.

Miraculously, God changed our spiritual hunger and thirst when he drew us to himself. He changed it instantly and permanently. He made us hunger and thirst for the right things—the eternally lasting good things. Our hunger and thirst for righteousness became part of our identity.

We have to retrain our thinking about who we are, but we don't have to change who we are. He has done that—the impossible part. He has caused us to be someone whose hunger and thirst is for the best food, the perfect food—him and all that he loves.

A bit further in Matthew 5, God's word gives some specific examples of what being in Christ and living righteously (by his standard) looks like on a very practical level. For instance, in verses 21–26, Jesus says that those belonging to him will not only not kill, they will not even be angry at a brother, and they will pursue peace. Look up the

following verses and describe what living righteously should look like from Jesus's perspective.

Matthew 5:27–30

Do not allow your heart to be corrupted with lust

Matthew 5:31–32

You can't use legality to mask morality

Matthew 5:33–37

Be fully impeccable and honor your words — speech is incredibly important and binding

Matthew 5:38–42

There's no room to get even; practice servant leadership and radical giving

"no paybacks" —Christ

Matthew 5:43–48

Love your enemies

Grow up spiritually and live as a fully embodied citizen of the kingdom of God now

Wow! How do we live there? The high standard seems to call for an impossible performance. But we can't perform to fulfill Jesus's standard. Rather, we must start by realizing that this is how we really want to live because he transformed us and placed a hunger and thirst within us to do so.

There is no doubt that developing and following good habits can surely help. Daily disciplines can help us live out who we are. Consider the following healthy disciplines we can engage in:

- We can crucify our sinful flesh—continually.
- We can walk in good works.
- We can study God's word in order to know him better.
- We can obey his commands that we find in his written word.
- We can spend time with others who belong to him.
- We can pray and commune with him.
- We can worship him.
- We can walk by the Holy Spirit.

Following these daily disciplines and practices won't cause us to be righteous or to want to be righteous. We have already been declared righteous, and despite our sinful flesh, we want to live in righteousness. The disciplines and practices are simply ways to help us walk in the path of righteousness. They are practices that will help us follow and fulfill our natural, God-given desires. The things Jesus spoke of in Matthew 5:21–48 are the things we really desire to do.

Which specific disciplines do you think you should focus on to help you better live out who you are?

Prayer & contemplation

Scripture reading

Journaling & fellowship & mentorship

How can you apply the truth of Ephesians 2:10 to help guard against letting good habits and disciplines turn into a system of works-based sanctification?

Salvation is god's gift start to finish

God does the making & the learning

He's gotten good work ready for us

Loving What You Have

Satisfaction

Jesus says that those who are hungry and thirsty for righteousness *will* be satisfied. Satisfaction is our inheritance. We will be filled and satisfied in every way—to the point of contentment.

> *Back to the example of the diet: If we can get over the hurdle of having to retrain ourselves to be hungry and thirsty for healthy food, we are then ultimately and eventually satisfied and filled with the things we have taught ourselves to be hungry and thirsty for. We find ourselves famished for lean meat, vegetables, fruit, and other good food. When we eat those good things, we fill up on them and are satisfied.*

Once again, God is the one who changed our spiritual hunger. There are no hurdles for us to jump over in that regard. It is done! It is finished! He accomplished our appetite changes with the blood Jesus shed on the cross. Because of Jesus's atoning sacrifice, we have been regenerated. He made a way for God to impute to us his righteousness and cause us to hunger for it.

Experiencing full satisfaction begins with remembering who we are in Christ. We are those who hunger and thirst for righteousness. We need not work hard to cause ourselves to be hungry and thirsty for the right things. We just need to be who we are. Then we need to eat and drink the things he has made us hungry and thirsty for. When we do, we will be satisfied. We have inherited satisfaction. It is ours already.

Here is a description of some of the things that have already brought us satisfaction:

- We have been satisfied by being delivered from sin and the power of sin.
- We have been satisfied by being made alive in Christ.
- We have been satisfied by being brought into union with Christ.
- We have been satisfied by being given a new identity.

- We have been satisfied by being given all of our inheritances, including a future eternal home in heaven.
- We have been satisfied by his grace and mercy.

Name some other things that God has given you that have brought real satisfaction.

○ Earthly family
○ Spiritual family & Communion
○ Holy Spirit's direction & guidance

Ultimately, we are filled with satisfaction because of the Holy Spirit. Scripture says that Christ's own are indwelt by and able to be filled with the Holy Spirit. The Holy Spirit resides within every person who is in Christ. The source of our satisfaction is actually living within us. He is the actual ultimate righteousness we hunger and thirst for. As he works in us inwardly, he makes our satisfaction an experienced reality.

John 14
16 And I will ask the Father, and he will give you another Helper, to be with you forever.

Consider the following passage of scripture:

Romans 8
3 By sending his own Son in the likeness of sinful flesh and for sin, he condemned sin in the flesh,
4 in order that the righteous requirement of the law might be fulfilled in us, who walk not according to the flesh but according to the Spirit.
5 For those who live according to the flesh set their minds on the things of the flesh, but those who live according to the Spirit, set their minds on the things of the Spirit.
6 For to set the mind on the flesh is death, but to set the mind on the Spirit is life and peace.
7 For the mind that is set on the flesh is hostile to God, for it does not submit to God's law; indeed it cannot.
8 Those who are in the flesh cannot please God.
9 You, however, are not in the flesh but in the Spirit, if in fact the Spirit of God dwells in you. Anyone who does not have the Spirit of Christ does not belong to him.

10 But if Christ is in you, although the body is dead because of sin, the Spirit is life because of righteousness.

11 If the Spirit of him who raised Jesus from the dead dwells in you, he who raised Christ Jesus from the dead will also give life to your mortal bodies through his Spirit who dwells in you.

What is the good news in these verses?

God will give me life – both spiritually and within my mortal body

How do the above verses relieve the pressure to perform?

God is the maker, creator, and savior

How are you encouraged by this passage of scripture?

My life matters – both my spiritual life and my mortal life as well – it's embodied and also eternal

Finally, we need to recognize that something wonderful happens when we are hungry and thirsty for righteousness and then satisfied in him. We bear fruit.

Think of a peach tree that is hungry and thirsty for fertilizer and water. If the tree feasts on something that is poisonous, it will surely shrivel and die. Even if the tree feasts on vegetables and juice, it still won't thrive. When the peach tree feasts on what it is hungry for (fertilizer and water) it thrives and bears fruit—peaches.

When we feast on righteousness, we are satisfied. When we are satisfied, we thrive and bear fruit. Jesus mandates that we bear fruit.

Philippians 1
10 And so be pure and blameless for the day of Christ,
11 filled with the fruit of righteousness that comes through Jesus Christ, to the glory and praise of God.

Jesus gives us an exact picture of what the fruit of righteousness—which is produced by the Holy Spirit—looks like.

Galatians 5
22 But the fruit of the Spirit is love, joy, peace, patience, kindness, goodness, faithfulness,
23 gentleness, self-control; against such things there is no law.

Read Galatians 5:19–21 and contrast the works of the flesh with the fruit of the Spirit listed above. What is significant about the difference between the terms works and fruit?

works = performance, effortful, striving
Fruit = producing, bearing, birthing
natural, generative,
Co-Creation with all of earth
faith & hope

God has made us who we are—hungry and thirsty for righteousness. He has provided satisfaction. When we are satisfied in him and he produces fruit through us, we experience joy. There is great freedom in being who we are.

Does the study of this particular Beatitude motivate you to change your approach to everyday problems and circumstances? In what ways?

So far, which of your attributes listed in the Beatitudes are you most amazed by? Why?

IDENTITY

WORTHY

loved

enough

I have always found that mercy
bears richer fruits than strict justice.

—Abraham Lincoln

———————

Therefore the LORD waits to be
gracious to you, and therefore he
exalts himself to show mercy to you.

—Isaiah 30:18

Those who are merciful give away
what they received from the highest
holy judge—God.

You Are Merciful

Blessed are the merciful,
for they shall receive mercy.

—Matthew 5:7

Those who are merciful in the context of the Beatitudes are uniquely merciful.

We tend to think of someone who extends mercy as someone in a place of power withholding punishment or harm. That kind of mercy is appreciated and gladly received, and we would likely classify the giver of that mercy as kind and gracious.

However, the merciful people Jesus spoke of go beyond just withholding punishment or harm. They offer relief—gospel relief that will go on into eternity.

The Truths in the Verse

Here are four truths relating to Matthew 5:7:

1. Those who belong to God have been given **mercy**.
2. Those who receive mercy are blessed.
3. Those who receive mercy are those who are **merciful**.
4. Those who belong to God are those who are merciful.

These truths lead us to rejoice in the reality that we are merciful. We don't have to work hard to make ourselves merciful. We *are* merciful. We are merciful and have unending access to God's mercy.

What the Verse Means

To better understand the meaning of this verse, it's helpful to note the difference between God's mercy and God's grace. His mercy and grace are closely connected yet different. The difference is important.

> **The merciful**
> The merciful are compassionate. They are willing to withhold punishment, take away misery, and provide relief. This willingness flows from an awareness that God has withheld punishment from them; he has taken away their misery and relieved their justly deserved, eternal suffering by redeeming them.
>
> They are motivated to help relieve others' suffering. The merciful are directed by God's moral law (which cannot be set aside or ignored) and also by God's merciful example in salvation.

> **Mercy**
> The mercy attributed to Jesus-followers is uniquely given by God. It is the expression of God's compassion. The primary demonstration of his mercy was providing a way to be saved for those who would repent and believe. The relief he provides is found in Jesus. God offers eternal life with him through Jesus. He is able to set aside the just eternal punishment due those who have sinned against him and who are at enmity with him and, instead, show them mercy.

Mercy takes away the misery, justly deserved. Grace is the help. Mercy is the relief. Mercy does away with consequences that are otherwise inescapable. Grace gives new life and standing, undeserved.

Read Hebrews 4:16. In your own words, describe the difference between God's grace and God's mercy.

Describe a recent time when God has given you help you didn't deserve. Describe how he has extended grace to you.

Describe a time when God has shown merciful compassion and provided escape from consequences. Describe how he has given you mercy.

If the grace of God contemplates man as guilty before God and therefore in need of forgiveness, the mercy of God contemplates him as one who is bearing the consequences of sin, who is in a pitiable condition, and who therefore needs divine help.[1]

—Louis Berkhof

We are in awe and wonder that our God would give us both grace and mercy. It seems that even if he chose to pardon us as sinners, his holiness would call for some kind of personal performance to measure up to his holiness. We know that our sin is an offense against him. But our merciful and gracious God is long-suffering. He is trustworthy and faithful. He keeps his promises.

Deuteronomy 4
31 For the LORD your God is a merciful God. He will not leave you or destroy you or forget the covenant with your fathers that he swore to them.

We know that he will have mercy on us because he says he will. We might deserve to be destroyed, but he will not destroy us. We might deserve his desertion, but he will not desert us. Not only that, he will provide relief.

In light of all this, it would be a great mistake to conclude that God doesn't care about sin, or even that he overlooks it. He *cannot* overlook it. God abhors sin. The evidence of that is the devastation that sinfulness brought upon this earth and the eternal consequences of those who persist in rebellion against him—those who choose to remain in Adam.

God, in his holiness, will not tolerate sin. His holiness calls for consequences. At his discretion, however, he will sometimes allow and use natural consequences as tools to discipline and teach. In his mercy, he might withhold consequences and extend relief. He has extended mercy

to us who are his own by exacting the ultimate consequences of our sin upon his Son, Jesus, on the cross. God is a God of mercy.

Our merciful God has graciously made those who belong to him merciful, too. Being merciful is part of our identity. In making us merciful, he has equipped us to be Christ-like.

The mercy we are designed to give is not self-exalting, but God-exalting. It is not a mercy motivated merely by pity for one who is suffering. By God's design, we can give mercy out of a heart of love and a desire for God's exaltation. We can be merciful—for his glory.

What are some situations in which you might extend Christ-like mercy to others? How would you offer relief?

How do you envision God might receive glory by your giving mercy to others?

Those who don't belong to the Savior and still bear the guilt of their sin have not experienced God's saving mercy. Therefore, they cannot even comprehend it. Mercy is not part of their identity; they are not equipped to give the kind of mercy God gives.

While it is true that some people who are not yet in the family of God are compassionate (some more than others), they cannot be merciful in a Christ-like sense. They can only be compassionate and merciful to a degree. They cannot be merciful in the same way that we can be merciful.

1 Peter 1
3 Blessed be the God and Father of our Lord Jesus Christ! According to his great mercy, he has caused us to be born again to a living hope through the resurrection of Jesus Christ from the dead.

1 Peter 2
10 Once you were not a people, but now you are God's people; once you had not received mercy, but now you have received mercy.

The religious leaders of Jesus's day knew nothing of this mercy. They were void of any God-exalting mercy. They did not comprehend it and lived from a self-centered, self-righteous, judgmental perspective.

Matthew 9
10 And as Jesus reclined at table in the house, behold, many tax collectors and sinners came and were reclining with Jesus and his disciples.
11 And when the Pharisees saw this, they said to his disciples, "Why does your teacher eat with tax collectors and sinners?"
12 But when he heard it, he said, "Those who are well have no need of a physician, but those who are sick.
13 Go and learn what this means: 'I desire mercy, and not sacrifice.' For I came not to call the righteous, but sinners."

As those without mercy, the Pharisees had a shortsighted, self-centered perspective. All they could see was a ceremonial problem—becoming contaminated by eating with sinners. Their lives were defined by a mechanical implementation of rules.

Something huge was at stake (Jesus and his kingdom), but they could not see it or understand it. Eternal sickness was about to be healed. In their pride, they were enslaved to the trivial, temporal issues of ceremonial purity.

Jesus said they needed to learn what true mercy is. He was never going to be interested in or impressed with empty sacrifices. He desires real mercy—his kind of mercy.

Over and over again, the Pharisees revealed their sin-sick hearts, and Jesus was righteously disgusted.

Matthew 23
23 "Woe to you, scribes and Pharisees, hypocrites! For you tithe mint and dill and cumin, and have neglected the weightier matters of the law: justice and mercy and faithfulness. These you ought to have done, without neglecting the others.
24 You blind guides, straining out a gnat and swallowing a camel!"

Their preoccupation with the trifles in life was offensive to the Savior. Sadly, without mercy they were living in bondage to their trivial man-made rules and superficial performance.

Describe a time when you chose to act unmercifully instead of mercifully. What feelings did you experience?

In what ways could God have been glorified if you had acted according to who you really are—merciful?

Those belonging to Jesus are merciful. We have been given and will be given mercy. We can live in freedom.

Being Who You Are

Merciful

We are not left on our own to understand how we might be merciful. Jesus modeled perfect mercy for us when he walked on this earth. His redeeming love embraced sinners of all kinds. He showed compassion. He often relieved immediate misery. Jesus's mercy was compassion in action, and it was all to his own glory.

Jesus showed mercy many times by healing people physically. He made the sick well and enabled the lame to walk. He gave sight to the blind, hearing to the deaf, and speech to the mute. He also wept with those in sorrow and comforted the lonely. He embraced little children.

Cite one recorded instance in the Bible of Jesus giving mercy and explain why it is particularly meaningful to you.

Read Ephesians 2:4–6. According to these verses, name some of things God has given you in his mercy.

Jesus took the opportunity to paint a vivid picture of how mercy can actually work. He was responding to the question of a cunning lawyer.

Luke 10
25 And behold, a lawyer stood up to put him to the test, saying, "Teacher, what shall I do to inherit eternal life?"
26 He said to him, "What is written in the Law? How do you read it?"
27 And he answered, "You shall love the Lord your God with all your heart and with all your soul and with all your strength and with all your mind, and your neighbor as yourself."
28 And he said to him, "You have answered correctly; do this, and you will live."
29 But he, desiring to justify himself, said to Jesus, "And who is my neighbor?"

Jesus's answer to the lawyer was a veiled way of saying that only those belonging to him can possibly love God with all their heart, soul, strength, and mind; only they can love their neighbor as themselves. In other words, only those who belong to him will receive his mercy, be able to extend the same kind of mercy, and also experience eternal life.

Jesus went on to tell the lawyer what we now know as the Parable of the Good Samaritan. It showcased the mercy we are empowered to give.

Luke 10
30 Jesus replied, "A man was going down from Jerusalem to Jericho, and he fell among robbers, who stripped him and beat him and departed, leaving him half dead.
31 Now by chance a priest was going down that road, and when he saw him he passed by on the other side.
32 So likewise a Levite, when he came to the place and saw him, passed by on the other side.

33 But a Samaritan, as he journeyed, came to where he was, and when he saw him, he had compassion.

34 He went to him and bound up his wounds, pouring on oil and wine. Then he set him on his own animal and brought him to an inn and took care of him.

35 And the next day he took out two denarii and gave them to the innkeeper, saying, 'Take care of him, and whatever more you spend, I will repay you when I come back.'

36 Which of these three, do you think, proved to be a neighbor to the man who fell among the robbers?"

37 He said, "The one who showed him mercy." And Jesus said to him, "You go, and do likewise."

This parable illustrates at least five characteristics of Christ-like mercy.

- Mercy has no qualifications. It can be given to friend or enemy alike (verse 33).
- Mercy recognizes a need (verse 33).
- Mercy comes from the heart (verse 33).
- Mercy offers relief (verse 34).
- Mercy is sacrificial and generous (verse 35).

Keeping an others-centered perspective, an open and compassionate heart, and a willingness to relieve and give sacrificially is what being merciful looks like.

- When people aren't lovable, we can love them anyway.
- When a family member mistreats us, we can overlook their offense.
- When our spouse doesn't honor us, we can honor them.
- When our children disobey and disappoint us, there are times we can forego punishment and take the opportunity to lovingly teach them.
- When our friends let us down or even betray us, we can let it go.
- When neighbors aren't neighborly, we can serve them.
- When those we work with undercut us, we can respond with kindness.
- When people in public are irritable and pushy, we can be gracious and not return evil for evil.
- When our enemies despise and reject us—even plot against us— we can embrace and love them.

Driven by a desire to glorify God, we can give away mercy that looks just like the mercy that Christ gave. That is the kind of mercy we are made for.

There is great joy to be found in being merciful. Name a couple of times you have experienced real joy in being who you are—merciful.

Loving What You Have

Mercy

We are merciful by design, and we have been given mercy—freely. We have not obtained God's mercy; he has given it as a gift of his love. It is because of the mercy of our heavenly Father that we draw breath each day.

> *Lamentations 3*
> *22 The steadfast love of the LORD never ceases; his mercies never come to an end;*
> *23 they are new every morning; great is your faithfulness.*

Because of God's mercy, there is hope—always—no matter how we have failed or sinned. Our inheritance of mercy doesn't give us freedom to sin. Rather, it gives us freedom from the bondage and lasting effects of sin.

What a travesty it would be to live in bondage to our sin when mercy is ours.

Czar Nicholas of Russia used to wander about his military camps and barracks, clothed as an ordinary officer, in order that he might know, without being known, what was going on.

Late one night when all lights were supposed to be extinguished, the czar was making one of those tours of inspection. He noticed a light shining under the paymaster's door and, quietly opening it, stepped inside, intending to have the offender punished. A young officer, son of an old friend of the czar, was seated at a table, his head resting on his arms, and sound asleep. The czar stepped over to awaken him, but before doing so, he noticed a loaded revolver, a

small pile of money, and a sheet of paper with a pen that had fallen from the hand of the sleeping man. The light of the little candle let the czar read what had just been written, and in a moment he understood the situation.

On the sheet of paper was a long list of debts—gambling and so on. The total ran into many thousands of rubles. The officer had used army funds to pay these wicked, reckless debts, and now having worked until late into the night trying to get his accounts straight, had discovered for the first time how much he owed. It was hopeless; the pitifully small balance on hand left a huge deficit to be made up. On the sheet of paper, below the terrible total, was written this question: "Who can pay so great a debt?"

Unable to face the disgrace, the officer had intended to shoot himself, but completely worn out with sorrow and remorse, he had fallen asleep.

As the czar realized what had happened, his first thought was to have the man immediately arrested and, in due course, brought before a court-martial. Justice must be done in the army, and such a crime could not be overlooked.

But as he remembered the long friendship with the young officer's father, love overcame judgment, and in a moment, he had devised a plan whereby he could be just toward the army and yet justify the culprit. The czar took up the pen that had dropped from the hand of the wearied, hopeless offender and with his own hand answered the question with one word—Nicholas.

The young officer awakened soon after the czar had gone and took up his revolver to end his life, but as he did so, his eye caught the answer to his question. In bewildered astonishment, he gazed on that one word—Nicholas. Surely such an answer was impossible! He had some papers in his possession that bore the genuine signature of the czar, and he quickly compared the names, for it seemed too good to be true. To his intense joy, yet bitter humiliation, he realized that his czar knew all about his sins, knew the utmost of his mighty debt, and yet, instead of inflicting the penalty he deserved, had assumed the debt himself and justified the debtor.

Joyfully and peacefully he lay down to rest, and early the next morning bags of money arrived from the czar sufficient to pay the last cent of "so great a debt."[2]

While we can be amazed at the mercy of the czar, we should be more amazed at the mercy of God. Imagine the scene for you and me:

We are on trial in God's courtroom. He is the judge; we are the guilty. The verdict is a foregone conclusion. Our sentence will be nothing less than terrifying. We will be banished to a place of unimaginable eternal suffering.

After hearing the chilling words "guilty eternally," the judge does something we don't expect. He steps off the bench and calls his son from the wings. He declares that his son will be punished in our place. He withholds our deserved punishment. Then, he goes even further.

He declares that not only will we not be banished to a place of unimaginable and eternal suffering, but he has also decided to adopt us and guarantee us a permanent and eternal home with him in a place where there is no suffering at all—a perfect place of joy and comfort. From the moment he declares our adoption, he also declares that the mercy he has given us will be ongoing. As sons and daughters, we can count on him to give us mercy—always.

God's mercy leads and enables us to repent of our sin and go on to flourish. We need not walk in condemnation.

It can be difficult to rest and receive God's mercy when we are burdened with an abiding sense of guilt. We intuitively know that payment is required for our sin—that the demands of justice must be met.

When those thoughts and feelings assault us, we must look to the gospel and remember the wonder and beauty of what Jesus did for us on the cross. He made the payment for our sin so the Father could give us mercy and we could receive his mercy.

In contrast, if we strive to deserve or earn mercy, then mercy becomes out of reach. Earning mercy (an oxymoron in itself) would be about saving ourselves. And self-salvation is about self-glory.

Additionally, resigning to live in despair over our failures completely misses God's mercy and never brings him glory. God hates sin, but he loves us, forgives us, and offers relief. Mercy is ours. Accepting and relying on his ongoing mercy brings him greater glory.

Thriving and flourishing in the attribute he has gifted us with—mercy—brings him greater glory. Receiving the mercy he freely provides pleases him.

Describe a time when you gave in to sin, repented of your sin, and then experienced God's amazing mercy.

Explain how God was glorified by your embracing his mercy.

As we continually access and experience God's mercy—knowing that we need it and that we have it—we are free to live according to who we are (merciful) and experience the joy of giving mercy away. We can offer those around us relief, and it pleases us because when we do that, we are being who we really are.

Read and rest in Psalm 23:6. Explain how the truth of this verse brings freedom.

Write a prayer thanking the Lord for the promise that you can rely on his mercy—always.

Nobody is more dangerous than he
who imagines himself pure in heart;
for his purity, by definition
is unassailable.

—James A. Baldwin

———————

Who shall ascend the hill of
the LORD? And who shall stand
in his holy place?
He who has clean hands
and a pure heart.

—Psalm 24:3-4

Those who are pure in heart have
been cleansed from sin and renewed
in righteousness.

You Are Pure in Heart

Blessed are the pure in heart,
for they shall see God.

—Matthew 5:8

When Jesus spoke of the pure in heart, he was describing those who have a heart that beats for God and God alone. It is not that they do not sometimes chase after other things and even treasure other things. They do. But when they do, they are not genuinely following their hearts.

God rules and reigns over their hearts—the core of their beings. He has made their hearts pure in order to inhabit them, to rule and reign there. The pure heart is his kingdom's domain, and the pure heart affords the ability to know and see him.

The Truths in the Verse

This beatitude has to do with the innermost part of who we really are. Here are the truths of Matthew 5:8. They are connected to our hearts.

1. Those who belong to God have been given the ability to **see God**.
2. Those who see God are blessed.
3. Those who see God are those who are **pure in heart**.
4. Those who belong to God are pure in heart.

What the Verse Means

Of all the attributes that Jesus declared are true of those who belong to him, this is perhaps most difficult to comprehend and embrace. If we are honest, we struggle with the idea that we are pure in heart.

It is important once again to renew our thinking and remember that all the incredible attributes found in the Beatitudes are indicatives, not imperatives. We don't have to work to achieve them. In other words, they should be blessings for us, not burdens. We are blessed to be pure in heart.

No, the Beatitudes are not laws. They aren't steps or tips. These blessings are good tidings! They are announcements of something happening, not instructions or things to do.[1]

—Jared Wilson

The pure in heart
Those with pure hearts are changed at their core by the blood of Jesus. Their heart is cleansed from sin and purified. It is renewed in righteousness.

Titus 3
5 He saved us, not because of works done by us in righteousness, but according to his own mercy, by the washing of regeneration and renewal of the Holy Spirit,
6 whom he poured out on us richly through Jesus Christ our Savior.

The pure heart is clean and clear. It is not divided or self-deceived. It is sincere. It is authentic.

See God
Without a pure heart, we cannot see or even recognize God. The pure in heart can see God in the sense that they see him with eyes of faith. They can see him spiritually. They can see him through the scriptures. They can see him through his creation. Someday they will see him in the brilliance of all of his glory in the kingdom of heaven.

Because of Jesus's words in Matthew 5:8, we can say with confidence, "I am pure in heart." On the face of it, this could seem proud and boastful. Beyond that, we might be prone to wonder whether or not it can possibly be true.

We know through the scriptures and by experience that we are sinners. We are saved sinners—but sinners, still. In fact, coming to terms with our depravity is a process in and of itself. We understand that it was only by his grace that God gave us an awareness of the plight of our human condition. Knowing and embracing the reality of our sinful status before a holy God was the first big step toward our being changed, made new, and adopted into his family.

Romans 3
10 "None is righteous, no, not one;
11 no one understands; no one seeks for God."

According to 1 John 1:9–10, what two things can we be certain of?

In your own words, describe your understanding of your own depraved and unrighteous condition.

We are reminded again and again that we sin every day, perhaps (sadly) even many times a day. We are commanded to continually confess our sins. Yet Jesus says that we have pure hearts.

So how should we think about this apparent paradox? How can sinners claim to have pure hearts?

The Pure Heart

In order to reconcile the truth that we have a pure heart yet still sin, we need to clarify the use of the word *heart* in this verse. In the Bible, *heart* can refer to diverse concepts. For example, sometimes it is referencing how a person feels (see Psalm 16:9 where the psalmist says his heart is glad).

We tend to separate and compartmentalize the heart and the mind. We usually connect feelings to the heart and logic to the head. For example, we might say, "She is all heart and no head." By that, we mean that a person is driven by feelings over intellect. We separate the two.

But when Jesus refers to the heart in Matthew 5:8, he is not separating the mind from **the heart**. He is referencing a *whole* heart; that is, the center of our entire inner being that encompasses the heart, the soul, and the mind.

> **The heart**
> From God's viewpoint, the heart is the center of a person's being—the core. The heart includes emotions, intellect, and will. The heart is where God resides within us and where he does his work.
>
> God must rule the heart. The heart he rules must be pure because he will not tolerate sin. The heart he rules is pure because he resides in and rules it.

Think about God's desire for a pure heart. In the beginning, God created man with a sinless, pure heart. It was only after Adam's sin that each person entered the world with a heart twisted and tainted by sin—completely unacceptable to God.

Genesis 6
5 The LORD saw that the wickedness of man was great in the earth, and that every intention of the thoughts of his heart was only evil continually.

Romans 5
12 Therefore, just as sin came into the world through one man, and death through sin, and so death spread to all men because all sinned.

Because of Adam's sin, as descendants of Adam, every human heart begins in rebellion against God. Every human heart is a mini-kingdom of self-rule. God will not inhabit that kind of heart. He must purify it in order for it to be a place for God-rule.

When we become new creatures, God regenerates our hearts. He spiritually purifies our hearts. We are born again.

Giving us pure hearts is fundamental in God's work of grace on our behalf. The new heart is designed to be ruled by him alone and centered on him alone. The new heart is pure.

Read Proverbs 4:23–27. According to these verses, how are we admonished to steward our hearts?

According to Deuteronomy 4:29, what is God's desire for your heart?

Sinful Flesh

Understanding what the Bible calls *flesh* will also help us reconcile the paradox of how a person with a pure heart can still sin.

When Jesus says that we have pure hearts, he doesn't imply that we no longer sin. (We are not living in a state of sinless perfection.) We have pure hearts, and we also have sinful flesh. Until we reach heaven, we will still be prone to sin in the flesh.

1 John 1
8 If we say we have no sin, we deceive ourselves, and the truth is not in us.

It is apparent that we are sinful. We know it through the conviction of the Holy Spirit and through bitter experience. But what exactly is our sinful **flesh**? It can't be part of our hearts because our hearts are pure.

When the Bible refers to flesh, it may refer to several concepts. Some are quite distinct. Flesh might be used in a very literal way, almost like our word *meat*. It can also refer to humanness, without any implication of moral impurity (e.g., the fact that Jesus came "in the flesh").

> **Flesh**
> *Our sinful flesh is the part of us that consists of the residual habits and desires of our original sinful nature. Our experience of sinful flesh is not limited to external (bodily) expressions. We also experience it internally, even in our desires.*

Yet a primary scriptural use of flesh refers to the remaining sinfulness of those who have been made new and given pure hearts. Those with new identities in Jesus still struggle with this flesh.

Read Galatians 5:19–21. Name the works of the flesh listed.

What are some works of the flesh you struggle with?

Our pure heart and our sinful flesh aren't compatible. The sinful flesh we were born with initially, which exists in our bodies both externally and internally, wars against the new spiritual heart God has given us.

A friend of mine was describing what happened when her uncle underwent a heart transplant. The heart he was born with wasn't working well. He was given a new heart—one that did work well. As often happens, his body initially began to reject the heart. We might even say that his body began to wage war against his new heart.

In a sense, our sinful flesh rejects—wages war against—our new heart. Our new heart works very well. It is pure, and God's spirit resides there. It doesn't ultimately surrender to sinful flesh.

One day, the battle will be over. God will finally rid us of our sinful flesh. Until then, yes, we can say that we have pure hearts—because we do. And, yes, we still sin because we are not yet rid of our sinful flesh. We are blessed because, in spite of our sin, we can see God. We can see him now, and we will see him later in all of his glory. He guarantees it.

Being Who You Are

Pure in Heart

Remember the Huguenards? They were Huguenards, but were they acting like Huguenards? We are those with pure hearts, but do we act like those with pure hearts?

This is difficult because it is not as simple as just following our pure hearts. We must also overcome our sinful flesh. We know that we are pure in heart spiritually, yet experientially we are still contending with our leftover sinful flesh. We are still in the middle of the battle. As the Bible tells us, the flesh is literally at war with the Holy Spirit who resides in our pure hearts.

Galatians 5

17 For the desires of the flesh are against the Spirit, and the desires of the Spirit are against the flesh, for these are opposed to each other, to keep you from doing the things you want to do.

So we struggle to put to death the desires of our flesh (Romans 8:13, Colossians 3:5) and follow our pure heart. Notice that Galatians 5:17 says that the battle keeps *you* from doing what *you* really want to do.

Our pure heart is part of our real identity. We cannot lose our pure heart. It is part of what defines us. But we must actively choose whether to follow the Holy Spirit or follow the pull of our sinful flesh. For now, our struggle is ongoing.

Read Romans 7:15. How did Paul describe his struggle against sin? Name some ways you identify with Paul in his struggle.

Name some of the specific desires of the flesh that you deal with. Take some time to be actively "poor in spirit" and ask for God's help in putting those desires to death.

Regardless of our choices, our position with the Father is secure. Our true identity doesn't change. We could call this a judicial security. However, because of who we really are, sin will have a great effect on us if we follow the desires of our flesh.

When we, the pure hearted, choose to sin, we feel cut off from the one who rules our hearts. We don't walk with him in spirit and in truth. We are relationally estranged. We suffer consequences from sin. We cannot thrive. We aren't being who we really are.

King David experienced being cut off from God.

Psalm 66
18 If I had cherished iniquity in my heart, the Lord would not have listened.

He followed the desires of his flesh. He committed adultery and murder. And because of his pure heart, he felt a kind of unimaginable pain. He cried out to the Lord.

Psalm 51
10 Create in me a clean heart, O God, and renew a right spirit within me.

If you have followed the desires of your sinful flesh, here are some practical steps to take toward returning to authentic, consistent living:

1. Remember who you are through God's grace in Jesus.

1 Corinthians 6
20 For you were bought with a price. So glorify God in your body.

2. Repent of (acknowledge and turn from) sin and ask for the cleansing always available through Jesus.

1 John 1
9 If we confess our sins, he is faithful and just to forgive us our sins and to cleanse us from all unrighteousness.

3. Chase after the things that a pure heart should treasure—the things of God.

Matthew 6
21 For where your treasure is, there your heart will be also.

When Jesus says that where our treasure is, our heart will be, he gives an insight that will help war against our sinful flesh. If we actively pursue treasuring the things of God, we will naturally be who we really are. Here is an example of how it can work.

Do you remember getting a toy when you were a child—one you really liked? Suppose it was a new stuffed animal. Do you remember what you did with your stuffed animal? No doubt, you held it and squeezed it tightly. Surely, you gave it lots and lots of attention. You gave it very special care. You probably gave it a special name. Think about how you protected it. You wouldn't stand for anyone mistreating it. You took it everywhere with you—everywhere your mom would let you take it. If you couldn't take it, you would grab it up the minute you got home. You cuddled it and held it tightly at night—all through the night. You loved it and let everyone know how much you loved it.

Your stuffed animal became the thing you thought about most, protected most, and loved most. It became your treasure. Maybe you still have it tucked away in a box somewhere because you treasured it. Your heart was given over to the thing you treasured.

When you chase after the things of God (i.e., give your time to the things of God and love the things of God), your heart is right where it belongs—wrapped around the right treasure. A pure heart is designed to treasure God.

When we treasure other things, we force our pure heart to pursue something it doesn't desire and cannot tolerate. It is unnatural. It is painful. Our pure heart wasn't made to treasure anything other than God. Where your treasure is, there will your heart be also.

Apart from the things of God, what things do you actively treasure?

What would it look like for you to treasure the things your pure heart really craves?

Loving What You Have

The Ability to See God

God has changed the hearts of those who began as sons and daughters of Adam but are now his own. Instead of resisting or shunning the evidence and proof of God's being, the pure in heart can truly *see* him. In one sense, we have been blessed with the ability to see God now—already. In another, we will finally see him one day in the full kingdom of heaven in all of his glory.

Seeing God Now

John Piper describes ways in which we are able to see God in what some have called the shadowlands, the here and now. He suggests three specific ways we can experience seeing God in the waiting.[2]

1. When We Draw Near in Prayer, We See God

According to Hebrews 4:16, we can "draw near to the throne of grace." God is our King, and he sits on his throne. He has granted that we can come into his presence. Being in the presence of a king implies seeing him in his power and authority. So we bow our heads in humility and fall before our King's throne, praying for what we need.

> *Hebrews 4*
> *16 Let us then with confidence draw near to the throne of grace, that we may receive mercy and find grace to help in time of need.*

We go into his presence, and we see him. We can seek (and see) him continually.

> *Psalm 105*
> *4 Seek the LORD and his strength; seek his presence continually!*

Think of what your life would be like if you could not come into God's presence. How is your life affected daily by being able to go into his presence?

2. When Awestruck by His Glory, We See God

Virtually all of our spiritual sight in this life is mediated to us through the word of God or the work of God in providence. We see images and reflections of his glory. We hear echoes and reverberations of his voice.

Examples of being awestruck by his glory are as varied as people are varied. Sometimes, we are awestruck by his glory when we read a portion of scripture that reveals more of who he is. At other times, we see circumstances coming together in a way that could only happen through his orchestration. We look at all he created and marvel at all he has made. We see him and are awestruck by his glory.

Psalm 19
1 The heavens declare the glory of God, and the sky above proclaims his handiwork.

Describe a time when you experienced God's glory in a meaningful, striking way.

3. When Comforted by His Grace, We See God

Finally, seeing God is being comforted by his grace. Again and again, the psalmists cry out to God that he not hide his face from them.

Psalm 27
7 Hear, O LORD, when I cry aloud; be gracious to me and answer me!

8 You have said, "Seek my face." My heart says to you, "Your face, LORD, do I seek."
9 Hide not your face from me. Turn not your servant away in anger, O you who have been my help. Cast me not off; forsake me not, O God of my salvation!

"Hide not your face from me," is the same as saying, "Be gracious to me." That means that seeing the face of God is considered to be a sweet and comforting experience. When we are comforted by means of his grace (undeserved help), we see God.

List two or three specific ways God has either caused or allowed you to suffer since he made you pure in heart.

How have you been able to see God through those times of suffering?

Seeing God Later

Moses wanted to see God fully—in all his glory. So he asked. God gave a sweet answer. He said, "You cannot see my face, for man shall not see me and live" (Exodus 33:20). And then God protected Moses with his hand and let him see just a portion of his glory.

Exodus 33
18 Moses said, "Please show me your glory."
19 And he said, "I will make all my goodness pass before you and will proclaim before you my name 'The LORD.' And I will be gracious to whom I will be gracious, and will show mercy on whom I will show mercy.

20 But," he said, "you cannot see my face, for man shall not see me and live."

21 And the LORD said, "Behold, there is a place by me where you shall stand on the rock,

22 and while my glory passes by I will put you in a cleft of the rock, and I will cover you with my hand until I have passed by.

23 Then I will take away my hand, and you shall see my back, but my face shall not be seen."

Someday, all of us to whom he has given new identities and pure hearts will be able to fully see him in all his glory. That is guaranteed by Matthew 5:8. It has become part of our inheritance. Our eyes will be ready to be fully opened and unblurred by sinful flesh. We will be ready. According to John 17, Jesus is looking forward to that day with great joy.

Scripture offers a description of what it will be like to see him where he is. His glory will be the light.

Revelation 21

22 And I saw no temple in the city, for its temple is the Lord God the Almighty and the Lamb.

23 And the city has no need of sun or moon to shine on it, for the glory of God gives it light, and its lamp is the Lamb.

24 By its light will the nations walk, and the kings of the earth will bring their glory into it,

25 and its gates will never be shut by day—and there will be no night there.

26 They will bring into it the glory and the honor of the nations.

27 But nothing unclean will ever enter it, nor anyone who does what is detestable or false, but only those who are written in the Lamb's book of life.

What images enter your mind when you imagine what it will be like to finally see God in all his glory?

Seeing God in all his fullness is the ultimate thing our pure hearts long for. And until we see him in all his fullness, we can still thrive. God has given us a pure heart, and we can see him now. We do see him now.

Never Seeing God

In light of our great blessing, we should remember that those without pure hearts cannot see God. They cannot even recognize him. The Bible teaches that this is not so much an inability as it is an unwillingness. Romans 1 clarifies that all are guilty and responsible to God for their guilt.

> *Romans 1*
> *18 For the wrath of God is revealed from heaven against all ungodliness and unrighteousness of men, who by their unrighteousness suppress the truth.*
> *19 For what can be known about God is plain to them, because God has shown it to them.*
> *20 For his invisible attributes, namely, his eternal power and divine nature, have been clearly perceived, ever since the creation of the world, in the things that have been made. So they are without excuse.*
> *21 For although they knew God, they did not honor him as God or give thanks to him, but they became futile in their thinking, and their foolish hearts were darkened.*
> *22 Claiming to be wise, they became fools.*

The Pharisees of Jesus's day were those who could not see God. They gave no attention to the heart. They completely focused on externals. Their hearts had not been made pure, and there was no desire for them to be made pure.

God had given laws and ceremonies in order to both reveal who he was and to lead his people into trusting him as they fought sin and pursued purity. The Pharisees had taken those laws and twisted them, using them to give the mere appearance of a pure heart. They were satisfied to give a mere outward impression of purity.

> *Matthew 23*
> *27 "Woe to you, scribes and Pharisees, hypocrites! For you are like whitewashed tombs, which outwardly appear beautiful, but within are full of dead people's bones and all uncleanness."*

Jesus shredded their cloaks of hypocrisy. He exposed the superficiality of their so-called righteousness.

There is absolutely nothing people can do externally that will cause their sinful hearts to meet God's standard of perfect purity.

- External washing is not sufficient.
- Participating in ceremonies is not sufficient.
- Performing ritualistic works of righteousness is not sufficient.
- Human achievement is not sufficient.

But this is the path the Pharisees chose. How ridiculous and ironic! They mastered *trying* to do what only God could do—purify the inside. They replaced his standard of perfection with a doable, lower human standard. They chose a path of comparison to affirm their efforts and performance. That included:

- character comparison
- morality comparison
- ethics comparison
- goodness comparison
- works comparison
- knowledge comparison
- performance comparison

God is concerned with the heart. Those who are merely religious couldn't—and still can't—fix the heart. We should be so grateful that God has made our hearts pure. We should be humbled. Because of our pure hearts, we can see God. When we see God, we thrive.

Think of a few specific friends you know who cannot see God. Pray specifically that God would open the eyes of their hearts through the gospel and purify their hearts so they might see him.

The greatest honor history can bestow is that of peacemaker.

—Richard Nixon

————————

Turn away from evil and do good; seek peace and pursue it.

—Psalm 34:14

Those who are true peacemakers help bring about peace between God and man.

You Are a Peacemaker

Blessed are the peacemakers,
for they shall be called sons of God.

—Matthew 5:9

The value of a peacemaker is recognized by all humankind. The coveted Nobel Peace Prize demonstrates the worth the world places on those who successfully work toward making peace—specifically those who help make peace among the nations.

God is a God of peace and the omnipotent peacemaker over all the universe. He makes peace with those who are his enemies. Our God of peace has made those who belong to him (all his sons and daughters) like himself—peacemakers. As the children of God, we are naturally designed to help people find peace with God and make peace with each other.

The Truths in the Verse

The indicatives of Matthew 5:9 declare that we are, indeed, sons and daughters of God. They also portray the reality that we are made to make peace.

1. Those who belong to God are called **sons of God**.
2. Those who are called sons of God are blessed.
3. Those who are called sons of God are **peacemakers**.
4. Those who belong to God are peacemakers.

As sons and daughters of God, we are like our Father. We are also like our elder brother, Jesus—the ultimate and perfect peacemaker who walked on this earth in human skin.

> ### A peacemaker
> A true peacemaker is one who makes peace as a result of the work of the gospel. Jesus, the Son of God, is the supreme peacemaker (Ephesians 2:15–17, Colossians 1:20). Jesus's death on the cross made a way for peace between God and sinners.
>
> In sharing the gospel with others, true peacemakers (sons of God) can help bring about peace between God and people, and subsequently peace in relationships with others. Peacemakers delight in making peace wherever possible.

> ### Sons of God
> Sons of God in the context of Matthew 5:9 are those who belong to the heavenly Father. Jesus was and is the first and only begotten Son of God. Jesus is the elder brother of all other (adopted) sons of God. The adopted sons of God did not bear the image of God at birth; upon adoption, they are spiritually "born again" (John 3:3) to reflect their Father's character. To be called a son of God is to be declared like him in character.
>
> Daughter of God is included in the reference to son of God. Although the more general term "children" is not, in and of itself, inaccurate, retaining the "son" terminology is helpful because of the unique role, privileges, and responsibilities sons enjoyed in the ancient Semitic cultures from which the Bible comes. Still, females can also rejoice and claim identity as sons of God, just as males can rejoice in being included in the bride of Christ (2 Corinthians 11:2, Revelation 19:7–9).

There is no more godlike work to be done in this world than peacemaking.[1]

-J.A. Broadus

What the Verse Means

Peace is the absence of something horrible and the presence of something glorious. This varies from the perceptions of Jesus's day, and perhaps our own.

Politically, when Jesus spoke these words, they must have sounded shocking to the Zealots (many of whom were Sadducees). It was a time of inflamed political passions. Though Rome ruled firmly with an iron fist, the nation of Israel seethed in hatred and tension, knowing little genuine peace.

Spiritually, the Pharisees were comfortable striving to make peace with God on their own through good works and achievements. (Remember, they took pride in looking holy.) Their holiness was self-made. They tried to *achieve* peace with God.

The Pharisees and Sadducees were focused on being the spiritual elite. They had no desire to help anyone else find peace with God. Their religious systems made it exponentially harder to experience peace with God. In truth, there was no peace to be found because no one could meet their high, yet artificial standards of achievement.

Today, we have our own definitions of peace. The concept of peace is often defined as this:

1. a state of tranquility or quiet
2. freedom from disquieting or oppressive thoughts or emotions
3. harmony in personal relationships

Regarding the peacemaker in Matthew 5:9, the peace in view is unique. Jesus's peace is not the peace of the Pharisees and Sadducees of his day. His peace is not merely a state of tranquility or quiet. It does not guarantee the absence of conflict. It doesn't represent complete freedom from chaos—internal or external. It is not limited to harmony in personal relations.

Instead, God defines **peace** as the absence of something horrible and the presence of something glorious.

Ephesians 2
13 But now in Christ Jesus you who once were far off have been brought near by the blood of Christ.
14 For he himself is our peace, who has made us both one and has broken down in his flesh the dividing wall of hostility
15 by abolishing the law of commandments expressed in ordinances, that he might create in himself one new man in place of the two, so making peace,
16 and might reconcile us both to God in one body through the cross, thereby killing the hostility.

Psalm 85
10 Righteousness and peace kiss each other.

Romans 5
1 Therefore, since we have been justified by faith, we have peace with God through our Lord Jesus Christ.

> **Peace**
> *Peace is the absence of sin and the presence of righteousness.*

God loves peace. In the beginning, he created an ideal world, one of perfect peace. There was peace between the Creator and Adam. There was peace between Adam and Eve. There was peace between humans and animals. There was even peace among the animals. Originally, there was perfect peace in God's perfect world. There was peace because there was no transgression, no sin.

However, Adam sinned, and peace was marred. Subsequently, sin, heartache, and chaos spread to all people. Creation's peace was interrupted; perfect peace was obliterated.

Give a couple of examples from your own life right now of the absence of peace because of the effects of Adam's sin spreading to all people.

Name some ways that the sin of Adam has affected you personally in terms of the peace you experience.

The way back to peace is to address the root issue of sin. God, in his love and mercy, made a way for that to occur. The way back to peace is through the sacrificial death of his only begotten Son.



Colossians 1
19 For in him all the fullness of God was pleased to dwell,
20 and through him to reconcile to himself all things, whether on earth or in heaven, making peace by the blood of his cross.

Further on in the Sermon on the Mount, Jesus declared that he hadn't come to bring peace on earth. In reality, he came with a sword.

Matthew 10
34 "Do not think that I have come to bring peace to the earth. I have not come to bring peace, but a sword."

He came to provide a way for man to once again find peace—peace with God. The way to peace was through conquering sin.

Like Jesus, we must fight against sin. We must do what is necessary to be killing our sin. Puritan author John Owen famously said, "Be killing sin or it will be killing you."[2]

My husband, Michael, is a pastor and has been for many years. All through the years, we never lost sight of the reality that the church is made up of people. We knew that where people are, sinners are, and where sinners are, conflict happens.

Michael assumed the role of pastor of a church, and sure enough, in a little over one year, a major conflict ensued. It was bad, deep, and broad. We really didn't know what to do, so we sought counsel.

We found a conflict coach to steer Michael and me through the rough waters. She was brilliant. She was gifted. She was very discerning. She knew how to ask the right questions. I was so excited for us to get to work with her. Our hope was that God would use her to bring about reconciliation and peace in our complex and difficult situation.

But the process she pursued was totally unexpected. I thought she would spend hours hearing our side of the story and then more hours hearing the other side of the story. I thought she would come up with an ingenious plan to work things out to everyone's satisfaction. The coach arrives, and it's a win-win for us all—or at least for the good guys.

Instead, she began by helping Michael look into his heart—at his sin. Wow! He had already taken a real beating in the conflict. I could not understand why she would just heap on more pain.

And then, of course, she started in on me. I, too, had taken a beating. She wanted me to look more deeply into my heart to dig out my sin. She wanted to help me identify the idols of my heart.

I hated the whole process. Hours were spent looking at sin. It was awful—until it wasn't.

She was doing precisely what needed to be done. She was making us look at our sin to help us fight that sin. If there was any hope in the situation, we had to fight sin. We had to get rid of our sin.

She went on from us to the staff and the elders. She challenged them to search their hearts and confess their sins.

I wish I could report that it worked out perfectly. In too many ways, we didn't experience a happily-ever-after ending.

What is true, however, is that Michael and I ended up with real peace. The coach helped us learn how to better deal with our sin so we might know God's peace.

That is exactly what Jesus came for. He came to make a way for us to experience real peace with him.

Name some specific ways you can fight sin in your life.

James 5:16 admonishes us to confess our sins to each other. Name a person you would be comfortable making yourself accountable to in this way.

God is a God of peace. He *is* peace.

1 Corinthians 14
33 For God is not a God of confusion but of peace.

God has made those of us who belong to him peacemakers. When we engage our peacemaker quality, we look like our Father. We are obviously his.

Being Who You Are

A Peacemaker

As deity and the only sinless Son of God, Jesus was the perfect peacemaker. As our elder brother, he modeled what we should do naturally because we are sons of God. He has shown us how to do our Father's work.

As a peacemaker, Jesus revealed the gap between holy God and sinful people by living a life that demonstrated that his Father wouldn't tolerate sin. His perfect, sinless life revealed that there was a need for reconciliation between God and humans. What did that look like? What did Jesus actually do?

- He turned the other cheek, over and over again.
- He was silent when he could have screamed out.
- He asked redemptive questions, getting to the heart of every matter.
- He exalted the truth through stories, parables, and teaching.
- He was intolerant of sin even as he loved and accepted sinful people.
- He suffered to the extent of going to the cross in order to accomplish his Father's will.

That's what a true peacemaker looks like.

Psalm 34
14 Turn away from evil and do good; seek peace and pursue it.

This verse says that we should turn away from evil and do good. We should actively seek peace and pursue peace. According to Hebrews 12:14 and 2 Corinthians 13:11, what should a peacemaker do?

What comfort does the peacemaker have?

As peacemakers, we also can help others see their need to be reconciled to God. Like Jesus, we can help lead people to make peace with God.

We can also help our brothers and sisters in Christ make peace with each other. James 3 describes the peacemaker and shows what the peacemaker can accomplish.

> *James 3*
>
> *13 Who is wise and understanding among you? By his good conduct let him show his works in the meekness of wisdom.*
>
> *14 But if you have bitter jealousy and selfish ambition in your hearts, do not boast and be false to the truth.*
>
> *15 This is not the wisdom that comes down from above, but is earthly, unspiritual, demonic.*
>
> *16 For where jealousy and selfish ambition exist, there will be disorder and every vile practice.*
>
> *17 But the wisdom from above is first pure, then peaceable, gentle, open to reason, full of mercy and good fruits, impartial and sincere.*
>
> *18 And a harvest of righteousness is sown in peace by those who make peace.*

According to these verses, what are some other qualities (besides being peacemakers) of those who are in Christ?

Name some of the sins that can hold a peacemaker back from reflecting Christ as much as possible.

In his book *The Peacemaker*, Ken Sande proposes the "Four G's of Peacemaking." They are appropriate, effective steps for engaging in peacemaking when we find ourselves in the midst of conflict.

Four G'S of Peacemaking[3]

1. **Glorify God**

 Ask yourself, "How can I please and honor God in this situation?"

2. **Get the log out of your eye** (get rid of sin)

 Ask yourself, "How can I show Jesus's work in me by taking responsibility for my contribution to this conflict?" (Luke 6:27–28)

3. **Gently restore** (get rid of more sin)

 Ask yourself, "How can I lovingly serve others by helping them take responsibility for their contribution to this conflict?"

4. **Go and be reconciled**

 Ask yourself, "How can I demonstrate the forgiveness of God and encourage a reasonable solution to this conflict?"

Hebrews 12
14 Strive for peace with everyone, and for the holiness without which no one will see the Lord.

2 Corinthians 13
11 Finally, brothers, rejoice. Aim for restoration, comfort one another, agree with one another, live in peace; and the God of love and peace will be with you.

We don't make ourselves sons of God by making peace. We are peacemakers because he has made us peacemakers. Because we are peacemakers, we are naturally equipped to make peace.

Loving What You Have

Sonship

Many of us can relate to the idea of wanting to be part of a good family. Sometimes, people who have experienced painful or even abusive upbringings would give anything to be part of a better family. On occasion, someone actually marries a person because they cherish the idea of becoming part of a good and better family through marriage. They envision being in a family of character—in a family where they are truly loved and cherished.

123

How amazing it is to realize that in trusting Christ as personal Savior, we come into the best family anyone could ever be part of. We become true sons and daughters of the King of the universe, who is perfect in character and holiness. He is omnipotent, omniscient, and omnipresent. And his love for us goes beyond any love we have ever known or could ever know. In fact, he sacrificed his Son for us in order to make us his sons and daughters. That is deep and holy love.

All of the implications of becoming part of the family of God go so far beyond what we could think or imagine from a mere human perspective. Do we realize what we have in our sonship with God?

According to J. I. Packer, "If you want to judge how well a person understands Christianity, find out how much he makes of the thought of being God's child, and having God as his Father. If this is not the thought that prompts and controls his worship and prayers and his whole outlook on life, it means that he does not understand Christianity very well at all."[4]

We have been brought into the actual family of God through the Son of God. This is a precious reality. We are sons of God—brothers and sisters of Jesus.

Our adoption into God's family is important, but our sonship goes far beyond being adopted. In our sonship, we are actually given God-like character traits through his indwelling Holy Spirit. We are transformed and made like him.

D. A. Carson shed some light on what sonship meant in the ancient world:

And thus, sonship is bound up, in part, with family identity and vocation.[5]

He also noted that currently, human sonship is often proved by DNA tests. However, in Jesus's day, sonship was perceived in far more relational terms—terms wrapped up in social and family structures.

Sons did the same work as their fathers. Daughters typically did the same as their mothers. If the father was a farmer, the son was a farmer. If the mother stayed home and tended to the children, the daughter did the same.

When we work at making peace, we actually look like a true son or daughter, following in the footsteps of our Father, doing his work. Like father, like son.

It's not as though we have to work at becoming a peacemaker; the peacemaking ability of our Father runs through our veins. We can help make peace between God and humans, and between humans and humans because he has transformed us to do just that.

Being able to claim and hold fast to our inheritance of sonship is life-altering. We can live lives of fulfillment because of who we belong to and because we are like him. And when we follow in the footsteps of our heavenly Father—doing his work—we reflect him and his glory as much as we possibly can.

Someday when we are rid of our sinful flesh, we will reflect our Father perfectly. Until then, we need to remember that we are blessed to be called sons of God. He has called us sons of God and made us like himself. That should affect everything we do.

How is your heart affected by being called a son or daughter of God?

In light of who you are (a son or daughter of God), how are you motivated to be a peacemaker?

Persecution is the first law of
society because it is always easier to
suppress criticism than to meet it.

—Howard Mumford Jones

Whoever pursues righteousness
and kindness will find life,
righteousness, and honor.

—Proverbs 21:21

Those who are persecuted for the
sake of righteousness are persecuted
for doing right and for having a right
relationship with God.

You Are Persecuted for the Sake of Righteousness

Blessed are those who are persecuted for righteousness' sake, for theirs is the kingdom of heaven.

—Matthew 5:10

Christians living in America today have not yet experienced extreme suffering because of their choices to follow God. There is still freedom to choose to live according to God's standards. So it is hard for us to relate to the idea of persecution in general.

Yet Jesus proclaims that those who belong to the God of heaven *are* persecuted—and specifically for the sake of righteousness. It is not something that might happen. It *will* happen, and it *is* happening. Persecution for the sake of righteousness comes in various forms, and it is part of the identity of those who are in Christ.

The Truths in the Verse

We know we will be persecuted for the sake of righteousness because of Jesus's indicatives in Matthew 5:10:

1. Those who belong to God have been given **the kingdom of heaven**.
2. Those who have the kingdom of heaven are blessed.
3. Those who have the kingdom of heaven are those who are **persecuted for the sake of righteousness**.
4. Those who belong to God are those who are persecuted for the sake of righteousness.

As Jesus-followers, we are those who are persecuted for the sake of righteousness. Being persecuted is part of our identity.

Persecuted for the sake of righteousness
"Persecuted" comes from the Greek root word meaning to pursue or chase away. It ultimately came to mean to harass or treat in an evil manner.

We could paraphrase Matthew 5:10 this way: "Blessed are those who have been allowing themselves to be harassed or treated in an evil manner." The idea is that those belonging to God are literally given over to suffering on account of righteousness. They do not shrink back but willingly endure the persecution and remain committed to righteousness.

The kingdom of heaven
The kingdom of heaven is a description of the part of God's kingdom where he rules and reigns. It is the eternal representation of his kingdom and eternal righteous reign. God the Father, God the Son, and God the Holy Spirit share in their glory together there.

What the Verse Means

The persecution of those who belong to God started as far back as the beginning of time. In Genesis 3, we find Satan targeting and pursuing Adam and Eve, who were still in a state of sinless innocence. They were doing *only* what was right. In his evil and conniving way, Satan, as a serpent, chipped away at their desire to do right and obey God only. He tempted them to step out of righteous living and sin against God. They were persecuted by Satan. Their subsequent choice to sin resulted in the fall of humankind (Romans 5:12).

Satan and the forces of evil have not stopped persecuting for the sake of righteousness since the Garden of Eden. In Job 1:7, Satan declares that he is "going to and fro on the earth." He says that he walks up and down on it. First Peter 5:8 says he actually prowls around like a roaring lion, seeking someone to devour.

In the Old Testament, we have record of many of the prophets being persecuted.

- Jeremiah was repeatedly subjected to persecution (Jeremiah 12, 20, 26, 36, 37, 39, 43). He was finally stoned to death.

- Ezekiel fared little better than Jeremiah (Ezekiel 2:6, 20:49, 33:31–32).
- Amos was told to flee from where he was (Amos 7:10–13).
- Zechariah's labors were not appreciated (Zechariah 11:12).
- Moses, Samuel, Elijah, and Elisha suffered persecution.

Jesus confirmed that in the same pattern of the life and death of the prophets of old, all of those belonging to him would be persecuted. Being persecuted for the sake of righteousness is part of the identity of the followers of Christ.

It's not that we have a persecution complex; it's about our sonship. We are those who are persecuted because we are sons and daughters of God.

So even if our persecution experiences are not overt and obvious, rest assured that persecution will happen to us whether we are always aware of it or not. Being persecuted for righteousness' sake is part of our identity. Jesus linked that attribute to the inheritance of the kingdom of heaven. Just as we know we can count on being persecuted for having been declared righteous in Christ and for pursuing righteousness, we can nevertheless count on the security of an eternal home in heaven.

Being Who You Are

Persecuted for the Sake of Righteousness
Being persecuted for the sake of righteousness is not suffering for objectionable or foolish behavior. One who is persecuted for righteousness' sake is one who has been made righteous, lives rightly, and suffers for it.

Since the question is not *if* we will experience persecution but rather *when* and *in what ways,* it is good to consider some specifics regarding the persecution we will encounter and need to endure.

Persecution Is Inevitable

First, we must know that we *will* suffer persecution. We underestimate how offensive genuine righteousness really is. Righteousness causes offense. Our righteousness—the righteousness of Christ that has been imputed to us and changes us—is what prompts the persecution.

We are persecuted because we have received righteous status. Like Jesus, we are despised and rejected when we live in righteous ways. Following Jesus means living in righteousness, and that means persecution in this broken, rebellious world.

In a sermon on this verse, John Piper offers some specific examples of how this plays out:

- If you cherish chastity, your life will be an attack on people's love for free sex.
- If you embrace temperance, your life will be a statement against the love of alcohol.
- If you pursue self-control, your life will indict excess eating.
- If you live simply and happily, you will show the folly of luxury.
- If you walk humbly with your God, you will expose the evil of pride.
- If you are punctual and thorough in your dealings, you will lay open the inferiority of laziness and negligence.
- If you speak with compassion, you will throw callousness into sharp relief.
- If you are earnest, you will make the flippant look flippant instead of clever.
- And if you are spiritually minded, you will expose the worldly-mindedness of those around you.[1]

Offending those around us leads to a response. We may be insulted, mocked, marginalized, attacked, slandered, or ignored. In fact, Jesus is saying that we will be. We might lose friends, lose a position, lose a job, or lose favor with those who matter. We will be persecuted, and we will suffer.

Name some specific ways that you pursue righteousness (holiness).

How might people who are not sons of God be offended by your pursuit?

How should you respond to them (when they are offended) so they see Jesus in your example?

Consider how the ancient patriarchs would be persecuted in this day and age. Pastor James Montgomery Boice wrote:

No ancient historian would have thought twice about him [Job]. You can be certain that if Job had risen to wealth in New York City and had later died in poverty in Harlem, his name would not even have made the obituary columns of the New York newspapers. Yet the struggles of Job in his persecutions were viewed by God and angels.

It may take more grace and it may be a greater victory for a man to spend forty years of his life at the same desk in the same office watching other men being promoted over him because he will not do some of the things that are demanded of officers in his company than it would take for a John Hus to be burned at the stake for his testimony. And it may be more of a victory for a housewife to stay at home, raising her family in the things of the Lord while her nit-picking neighbors laugh at her for being humdrum and unglamorous, than it would be for a Joan of Arc to die at Rouen.

We may all take comfort in this, and turn to Christ for the victory. If we have not known persecution, even in little ways, let us search our hearts before him. And let us ask for that righteousness of character that will either repel men or draw them to our blessed Savior.[2]

Ordinary people like you and me may not be much different than righteous, persecuted Job.

Describe the difference between merely enduring persecution for the sake of righteousness and actually leaning into it—embracing it.

In what ways do you think leaning into persecution could benefit you as one of the sons or daughters of God?

Persecution Is Fruitful

Next, we must know that despite the suffering that accompanies persecution, there is blessing in persecution. We can and should embrace that being persecuted is part of our identity. There is great gain in it.

It's not that suffering persecution is easy. Indeed, it is painful. Immediately after Jesus reveals that we will be persecuted, he elaborates on the accompanying difficulties.

Matthew 5
11 "Blessed are you when others revile you and persecute you and utter all kinds of evil against you falsely on my account."

But no pity from God. We can believe there is blessing in our persecution because he says so.

Think of the ways you are blessed in being persecuted for the sake of righteousness:

- **You are comforted**

 Jesus comforts us in reminding us that we are not alone in our suffering for the sake of righteousness. Again, in context, he references the prophets of old who were persecuted and suffered (Matthew 5:12, Luke 6:23).

 Jesus himself suffered persecution—to the point of death on a cross. He understands our suffering.

2 Corinthians 1
5 For as we share abundantly in Christ's sufferings, so through Christ we share abundantly in comfort too.

- **You are assured**

 Our suffering for the sake of righteousness is confirmation that we belong to him. It affirms our true sonship. Like our Savior, we are rejected by men.

John 15

18 "If the world hates you, know that it has hated me before it hated you. 19 If you were of the world, the world would love you as its own; but because you are not of the world, but I chose you out of the world, therefore the world hates you.

20 Remember the word that I said to you: 'A servant is not greater than his master.' If they persecuted me, they will also persecute you. If they kept my word, they will also keep yours."

Read John 15:21–25. Explain the ultimate demise of those who are not persecuted for the sake of righteousness.

According to John 15:26–27, what encouragement is there for you and what opportunity do you have?

- **You are growing**

 Suffering for the sake of righteousness produces spiritual growth.

Romans 5

3 We rejoice in our sufferings, knowing that suffering produces endurance,

4 and endurance produces character, and character produces hope,

5 and hope does not put us to shame, because God's love has been poured into our hearts through the Holy Spirit who has been given to us.

- **You will know him better**

 Not only does Jesus understand our suffering, we can understand his. Knowing his suffering is a way for us to come to know him better.

We will be insulted as Jesus was insulted. Matthew 5:11 uses a word that means to reproach, revile, or heap insults upon. It has the idea of verbal abuse, attacking someone with vicious and mocking words. It is used in Matthew 27:44 of the mockery Christ endured at his crucifixion. It happened to him, and it will happen to us, and when it does, we can come away knowing him better.

We will be lied about as Jesus was lied about. That might be one of the hardest forms of suffering to endure. Our effectiveness for the Lord is related to our personal integrity. If the perception of our personal purity and integrity is tainted, our effective witness can be diminished. When we are lied about, we can enter into his suffering. He was lied about, too.

It is comforting that he knows us. But how much more comforting that we can know him and know how he felt in his suffering as the God-man.

Thomas Watson, the Puritan, wrote, "Though they be ever so meek, merciful, pure in heart—their piety will not shield them from suffering. They must hang their harp on the willows and take the cross. The way to heaven is by way of thorns and blood. . . . Set it down as a maxim—if you will follow Christ, you must see the swords and staves. . . .Put the cross in your creed."[3]

Read Matthew 16:24–27. Describe the benefit of taking up your cross by being persecuted for the sake of righteousness.

- **You will be given a reward**
 What is the ultimate reward for us in suffering persecution for the sake of righteousness? In Luke 6:23, Jesus says that our reward will be great. Author Haddon Robinson sheds some light on how we should think of this reward.

In one of Charles Schultz's *Peanuts* comic strips, Schroeder is playing the piano and announces to Lucy that he is learning all of Beethoven's sonatas. Lucy, leaning on the piano, says, "If you learn to play them all, what will you win?" Schroeder is upset and says, "I won't win anything." Lucy walks away and says, "What's the use of learning the sonatas if you don't win a prize?" Lucy was turned on by incentives.

My wife, a piano teacher, once tried to teach our children to play. We gave them quarters for practicing. My son and daughter were mercenary, so they practiced. Unfortunately, quarters were all they got out of their piano studies. Giving quarters was an incentive, but it wasn't a reward. No relationship existed between the quarters and the piano playing.

The reward of practicing is playing the Beethoven sonata. A man is mercenary if he marries a woman for her money because money is not the proper reward for love. But if a man marries the woman he loves, that's the reward. It's a proper connection.

What do we get if we suffer because of righteousness? The answer is, Him.[4]

- **You will glorify him**
 We can easily forget that God's glory is the main thing—always. He demands it. He deserves it. We can know we are blessed by leaning into being persecuted for the sake of righteousness, because when we do, he receives glory.

1 Peter 4
13 But rejoice insofar as you share Christ's sufferings, that you may also rejoice and be glad when his glory is revealed.
14 If you are insulted for the name of Christ, you are blessed, because the Spirit of glory and of God rests upon you.

- **You will rejoice!**
 The question is then, "How will we respond to persecution for the sake of righteousness?" Retaliation is not a righteous option. Resentment would only make us miserable. Depression leads to hopelessness. Jesus says that we are to be who we are and rejoice. When we rejoice, he is glorified. When he is glorified, we rejoice.

Matthew 5
12 Rejoice and be glad, for your reward is great in heaven.

*Of all of the benefits we experience in being those who are perse-
cuted for righteousness sake, which ones are the most striking to you?*

Explain what they mean to you personally.

Loving What You Have

The Kingdom of Heaven

In Jesus's day, people thought more in terms of kingdom than we do
today. They would have thought of the empire of Rome or the king-
dom of Israel. Jesus spoke of a different, unique kind of kingdom—the
kingdom of God.

As we saw when we considered Matthew 5:3, here is what we know
of the kingdom of God:

- His kingdom is everywhere. God is omnipresent—he has no
 spatial limitation.
- His kingdom includes this world. The world is presently in sin-
 ful rebellion against his holy and righteous reign. He is in the
 process of rescuing and redeeming it.
- His kingdom includes heaven, which is the eternal representation
 of his kingdom. It is his present home and his eternal home. It
 will also be the eternal home of all those who belong to him.

Upon our salvation, we were transferred into membership in the
kingdom of God (Colossians 1:13). When Jesus asserted that the kingdom
of heaven belonged to those who are poor in spirit (Matthew 5:3) and
those who are persecuted for the sake of righteousness (Matthew 5:10),

he was revealing that already in their possession were rights, citizenship, and guarantees of belonging to his kingdom.

Considering those who weren't—and aren't—in any present possession of any kind of lasting, worthy kingdom, how blessed to know for certain that we have the kingdom of heaven—God's eternal kingdom!

Haddon Robinson went on to say this:

As we live the Beatitude life, we enter into an eternal relationship with God. We may not understand all that means, but Jesus tells us it is great. To really have God because God has us, is to have an eternity in which we are the objects of His grace, mercy, and special love. When we come into a relationship with God, whatever that involves, we can only describe it by the word *great*.

Some things are certain. When we go through the waters, they will not overwhelm us. When we go through the fires, they will not wipe us out. In the midst of the persecution, He is with us.[5]

We are those who are persecuted for the sake of righteousness, and we have the kingdom of heaven. Amazing! Lean in to the persecution, love who you are, and rest in what you have.

Name some of the things you are looking forward to experiencing in the eternal kingdom of heaven. Explain how those things represent rest for you.

What will make heaven "home" for you?

One of the most beautiful realities we can bask in with regard to the kingdom of heaven is that Jesus is longing for us to be there with

him. It's not just that *we* are looking forward to being with *him*. *He* is looking forward to being with *us*. It is breathtaking to think that the almighty God of the kingdom of heaven wants to be with us—especially considering the fact that we were born rebels and have lived in rebellion.

John 17:22–24 speaks to how Jesus takes joy in the fact that those who are in his kingdom are in him as he is in the Father and the Father is in him. He loves that we (whom the Father has given him) are one with him and the Father. But not only that, his deep joy is for us to be with him in the place where he shares the Father's glory. He longs for us to see his glory there with him.

In the meantime, it's his desire that we put his glory on display for those who are still not in his kingdom in order that they might believe in him and come into his kingdom.

Describe some ways you think you have given God glory this side of heaven by embracing who you really are.

Epilogue

What a difference it makes when we live according to our identity! What a life of joy, satisfaction, and purpose—being who we really are! What influence we can have as we remember with eagerness and gratitude the inheritances we've been given and use them to their fullest!

For example, when we:

- are discouraged and cannot help ourselves spiritually, we remember that we are poor in spirit and can humbly ask for help. Our helper, who has given us the most we could ever receive (the kingdom of heaven), has limitless resources.
- are overwhelmed with the brokenness all around us, we remember that we are those who mourn and have comfort from the God of all comfort at our fingertips.
- are seemingly left behind by others who eagerly chase temporal things, we remember that we are the meek who have the guaranteed inheritance of the new and perfect earth.
- feel like we are drowning in a flood of immorality, we remember that we hunger and thirst for righteousness and are promised that we will be filled with the satisfaction only our Creator can provide.
- are wronged and seek to retaliate, we remember that we are merciful and receive his new mercies every day.
- question our security because of our ongoing struggles with sinful flesh, we remember that we are pure in heart and are assured that we will see God.
- find ourselves in conflict, either unexpected or seemingly inevitable, we remember that we are peacemakers and find our identity as sons and daughters of the God of peace.
- experience unfair treatment simply because we follow Jesus, we remember that we are the persecuted and know that despite current circumstances, ours is the kingdom of heaven. We will

live there with our brother Jesus, our Father God, and the Holy
Spirit for all of eternity.

Be assured that when you and I live according to our gospel-based,
God-given identity, we are living out who we really are, to his ever-
greater glory.

Through the good news of Jesus, we are, indeed, blessed. We are,
for certain, made well and given much.

You are who you are. Be who you are!

Copy (and possibly laminate) the following as cards to help study participants remember who they are and what they have.

Because of what He's done, and because I am His,

I am. . .

POOR IN SPIRIT

A MOURNER

MEEK

HUNGRY AND THIRSTY
FOR RIGHTEOUSNESS

MERCIFUL

PURE IN HEART

A PEACEMAKER

PERSECUTED

I have. . .

THE KINGDOM OF HEAVEN

COMFORT

THE EARTH

SATISFACTION

MERCY

THE ABILITY TO SEE GOD

SONSHIP

THE KINGDOM OF HEAVEN

Matthew 5:3–10

Because of what He's done, and because I am His,

I am. . .

POOR IN SPIRIT

A MOURNER

MEEK

HUNGRY AND THIRSTY
FOR RIGHTEOUSNESS

MERCIFUL

PURE IN HEART

A PEACEMAKER

PERSECUTED

I have. . .

THE KINGDOM OF HEAVEN

COMFORT

THE EARTH

SATISFACTION

MERCY

THE ABILITY TO SEE GOD

SONSHIP

THE KINGDOM OF HEAVEN

Matthew 5:3–10

Notes

Stuff You Need to Know

1. "The Academic Discourse delivered by Nicholas Cop on Assuming the Rectorship of the University of Paris on Nov. 1, 1533," in John Calvin, *Institutes of the Christian Religion* (Grand Rapids, MI: Ford Lewis Battles,1986), 363–72.

2. John MacArthur, "The Only Way to Happiness: Endure Persecution," Sept. 27, 1998, https://www.gty.org/library/sermons -library/90-198/the-only-way-to-happiness-endure-persecution-part-1.

You Are a Mourner

1. John A. Henderson, *Equipped to Counsel, Leader Notebook* (Louisville, KY: The Association of Biblical Counselors, 2008), 129.

You Are Hungry and Thirsty for Righteousness

1. Alistair Begg, https://gracequotes.org/author-quote/alistair-begg/.

You Are Merciful

1. Louis Berkhof, *Systematic Theology* (Grand Rapids, MI: Wm. Erdmann's Publishing Co., 1996), 72.

2. H.A. Ironside, *Illustrations of Biblical Truth* (Chicago, IL: Moody Publishing, 1945), 67–69.

You Are Pure in Heart

1. Jared Wilson, *The Imperfect Disciple* (Grand Rapids, MI: Baker Books, 2017), 42.

2. John Piper, "Blessed Are the Pure in Heart," March 2, 1986, https://www.desiringgod.org/messages/blessed-are-the-pure-in-heart.

You Are a Peacemaker

1. J.A. Broadus, *Commentary on the Gospel of Matthew* (Philadelphia, PA: American Baptist Publications Society, 1886), 92.

2. John Owen, "Quotes: John Owen," http://johnowen.org/quotes/.

3. Ken Sande, *The Peacemaker* (Grand Rapids, MI: Baker Books, 2004), 38.

4. J.I. Packer, *Knowing God* (Downers Grove, IL: InterVarsity Press, 1993), 201–202.

5. Interview with D.A. Carson, "Welcomed into the Family of God: Sonship in the Bible," July 5, 2016, *Desiring God,* https://www .desiringgod.org/interviews/welcomed-into-the-family-of-god-sonship -in-the-bible.

You Are Persecuted for the Sake of Righteousness

1. John Piper, "Blessed Are the Persecuted," March 16, 1986, https:// www.desiringgod.org/messages/blessed-are-the-persecuted.

2. James Montgomery Boice, *The Sermon on the Mount* (Grand Rapids, MI: Baker Books, 1972), 54.

3. Thomas Watson, *The Beatitudes,* http://www.biblebb.com/files /TW/tw-beatitudes.htm.

4. Haddon Robinson, *What Jesus Said about Successful Living* (Grand Rapids, MI: Discovery House, 1991), 90.

5. Ibid.